# FACES OF THE RAINFOREST

## THE YANOMAMI

*Photographs and journals by*
# VALDIR CRUZ

*Preface by*
Trudie Styler

*Essay by*
Kenneth Good

*Afterword by*
Vicki Goldberg

powerHouse Books
New York, NY

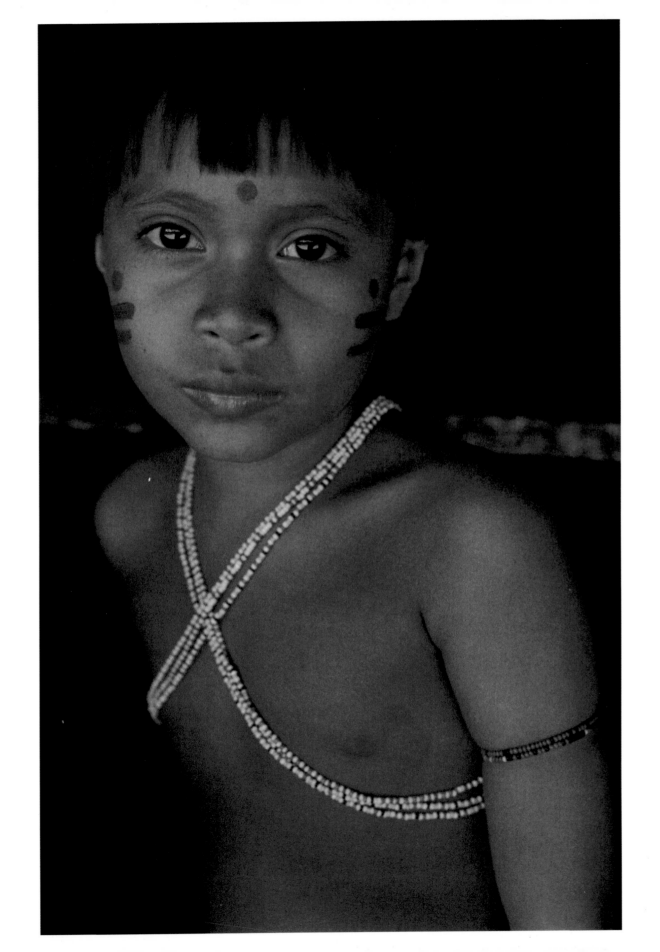

*Dedicated to the Yanomami*
*of Brazil and Venezuela*

# Preface

by Trudie Styler

Valdir Cruz's photographs and journals are wonderful for their ability to capture the moments and the individuals that are disappearing from the world's rainforests with such alarming speed. He depicts the indigenous people as ravaged by disease, hungry, and ill-equipped to fight off the encroachment of western man on their land, homes, and customs. Cruz is Brazilian, and his empathy and concern for his homeland and its people are apparent in every shot he takes. He shows us, with great simplicity and great power, what the reality of life in the rainforest is, and what must be saved.

My own connection to the rainforest is, like Cruz and anyone who has been there, deeply personal. My life changed twice during visits to the rainforests of Brazil. Sting and I made our first trip in 1989, when we met the Kayapo Indians and saw how they were suffering from the destruction of their forests. The villagers had fallen ill with the foreign diseases the miners had brought, and were unable to protect the rich land their ancestors had been living off of and cultivating for thousands of years. My husband and I were drawn to the lovely people of the village, and mesmerized by the words of the Kayapo's charismatic leader. He told us that what was happening to his rainforest would in time happen to the rest of the world.

As a mother of young children, the chief's warning rang within me like the deepest of truths. In one moment my gaze widened from just my life and my family and my home to the plight of the world we live in. The Kayapo's forest was being cut down, the villagers were losing their homes, the air around us was endangered. As a young girl in the '60s, I had listened to people talk of trying to change the world, but for the first time I felt personally empowered to take action. In fact, I felt that I didn't even have a choice–I had to do something as a mother and a woman to save the Kayapo children and protect the air that we breathe. When Sting and I returned home we co-founded the Rainforest Foundation.

When I returned to the rainforest later that year, it was at the behest of our Foundation's staff to check on the progress of our programs in Brazil, and I went reluctantly. I was at a personal low and felt I couldn't be of much help to anyone. I had lost all sense of inspiration, any feeling of power. I had been a professional actress for many years, but the offers of work had dried up quite dramatically and everything else in my life came crashing down. My slump probably had to do with the fact that I was getting older–I was in my mid-thirties–which meant there were fewer available parts. I began trying out for lesser roles, ones that I previously might have refused, but still with no luck. Everywhere I turned it seemed doors were closing. My failing career began to affect my personal life, too: Sting and I had been

together for several years and had two children, yet I stopped enjoying their beautiful faces and the home I was so fortunate to live in. I felt as if I didn't deserve any of it. I was convinced I was a failure.

After a couple of days in remote areas of Brazil, I realized I was holding back, being very quiet, mostly just watching other members of our team talk to the villagers. I was still consumed with what was happening to my career. That was when a group of little boys came up to me and asked if I would join them on a boat trip. I said okay, and they rowed us out to a sandbank in the middle of the Xingu River. They were playing and diving into the water, and I was thinking how lucky they were to live without the kind of worry that had followed me to the Amazon.

As we made our way back to shore in the little boat, five of the boys jumped into the water again. The translator explained that they were challenging the river. They had to swim in a particular direction to avoid being swept away by the Xingu's strong current. I liked the idea that they were challenging nature, and before I knew it, I had jumped in too. It was very uncharacteristic of me, especially at that moment, when I felt so incapable of doing anything.

I immediately felt the surge of the current beginning to take me. It was frightening–I'm not a strong swimmer–but it was also exhilarating. As I started towards shore, a thought came into my head: *If I make it, I will change my life.* I won't wait for the phone to ring telling me whether or not I got a part any longer. Why should I let others decide what I could do? When I finally emerged from the water–relieved, to be sure– I knew I had to take charge of my life.

The Kayapo Indians needed one million dollars to protect their land from being sold to loggers, and I quickly made it the Foundation's goal to get that money. It would be four long years before the land deal was ratified and finally handed back to the Kayapo, and the process became a huge learning curve for the Rainforest Foundation. In time I also became involved with human rights issues and documentary films. I felt I had something to communicate, and realized one way was by producing documentaries–the perfect role for me, it turned out. In 1990 I opened our production company, Xingu Films, named after the river that gave me back my sense of self.

When I look through Valdir Cruz's beautiful book, *Faces of the Rainforest*, I am reminded of the friends I made in the rainforests of Brazil years ago. It is sacred ground, filled with men and women of the purest spirit. I was twice blessed with a sense of purpose while visiting there, and allowed to find the deepest and best parts of myself. I am as deeply committed to saving the rainforest now as I ever was. I can still hear the Kayapo leader's prophetic words, and I still know them to be truth. Protecting the world's forests is an essential journey, because if we are able to save the indigenous people and their homes, we can save the best that is within ourselves.

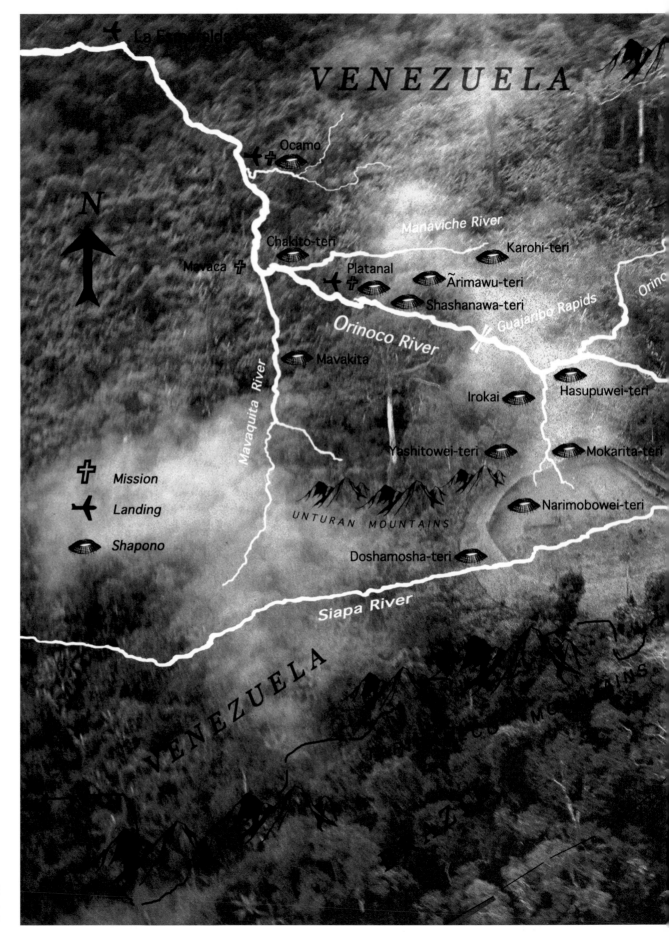

Map with Aerial view of
Narimobowei-teri,
Venezuela, 1996

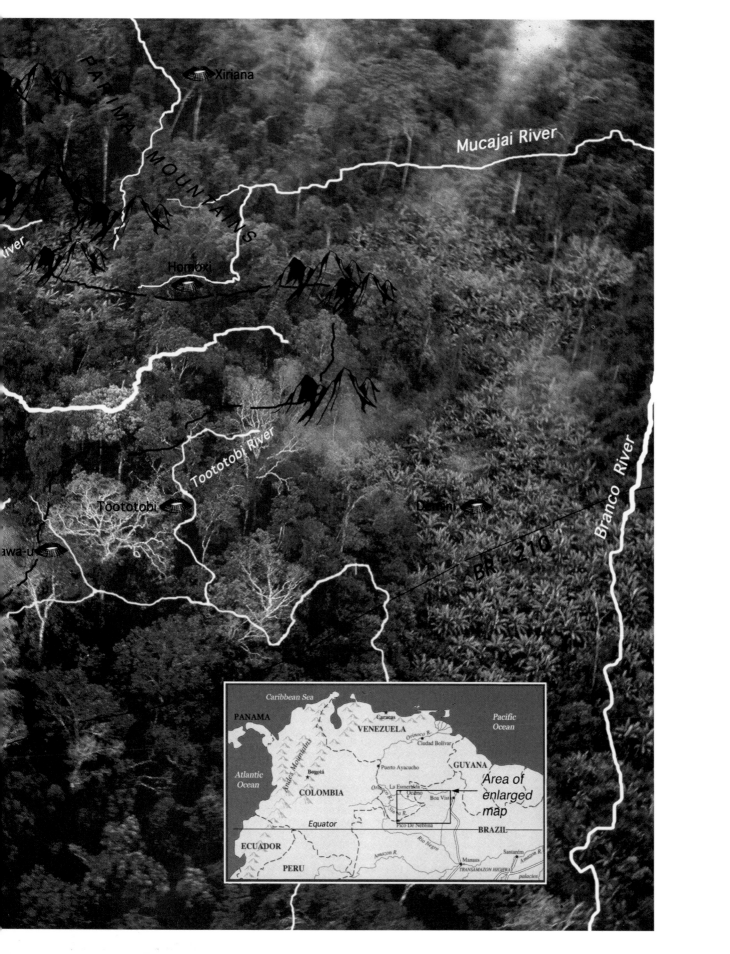

Xiriana

PARIMA MOUNTAINS

Mucajai River

Homoxi

Toototobi River

Toototobi

Demini

awa-u

BR - 210

Branco River

Caribbean Sea

PANAMA

Caracas

VENEZUELA

Pacific Ocean

Orinoco R.

Ciudad Bolívar

Atlantic Ocean

Andes Mountains

Bogotá

Puerto Ayacucho

GUYANA

La Esmeralda

Area of enlarged map

COLOMBIA

Orinoco R.

Ocamo

Siapa R.

Boa Vista

Equator

Pico De Neblina

BRAZIL

ECUADOR

Rio Negro

PERU

Amazon R.

Manaus

Santarém

Amazon R.

TRANSAMAZON HIGHWAY

palacios

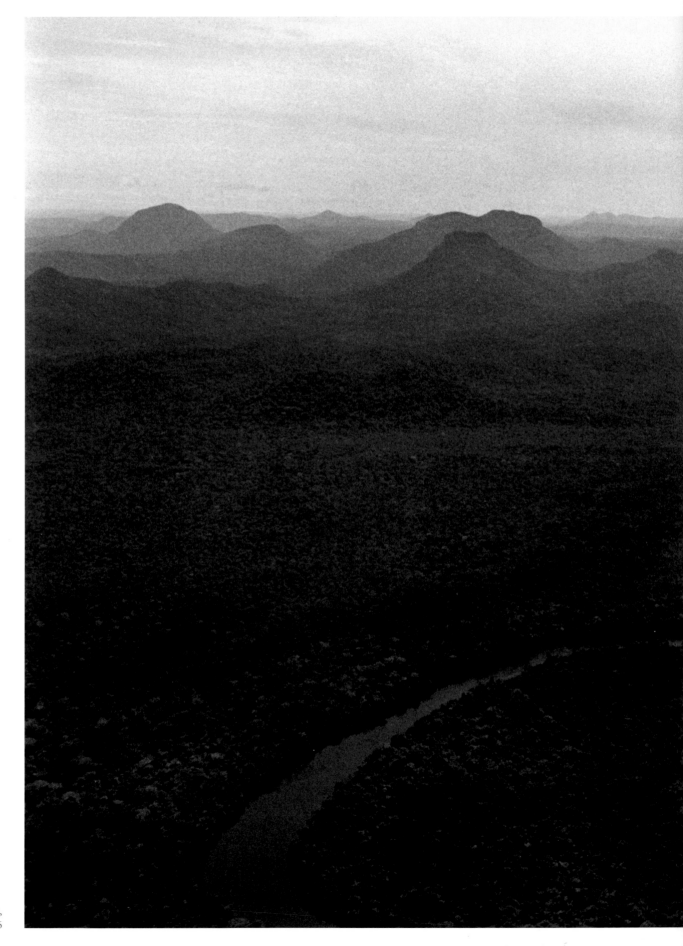

Aerial view of Siapa Sierras,
Venezuela, 1996

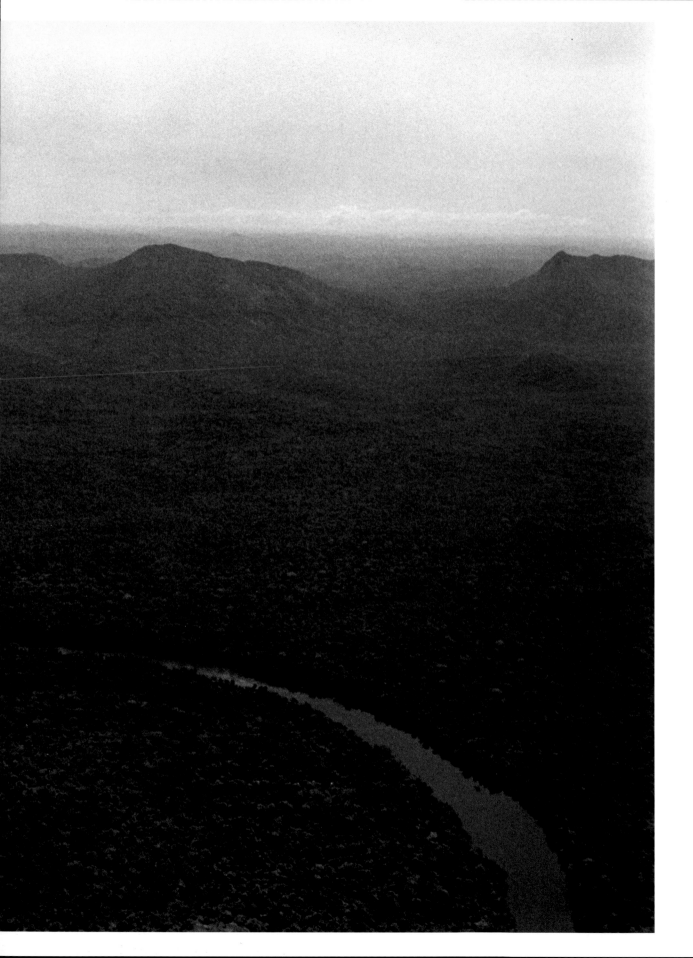

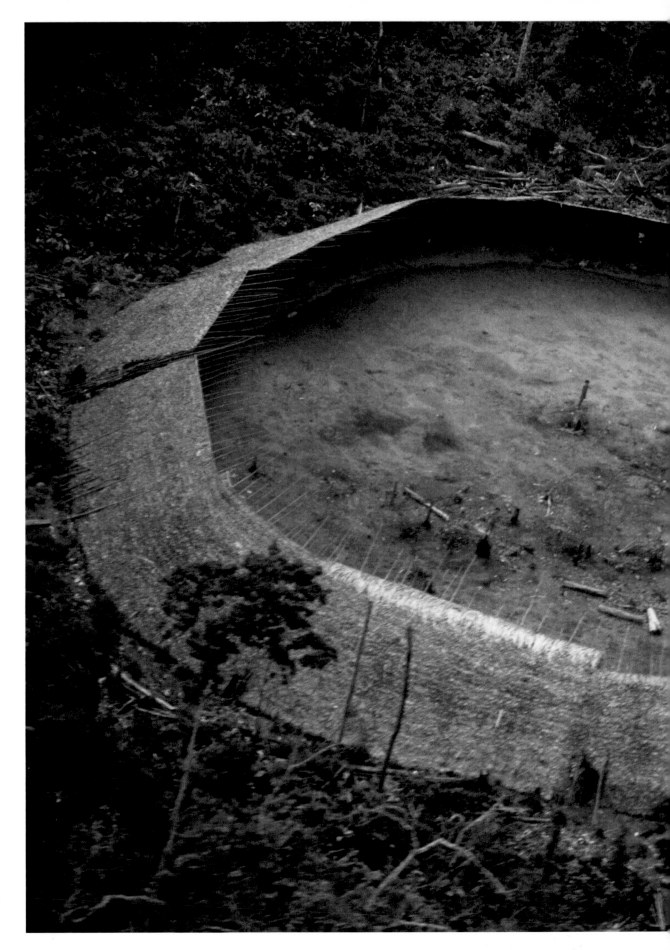

Aerial view of
Doshamosha-teri,
Venezuela, 1996

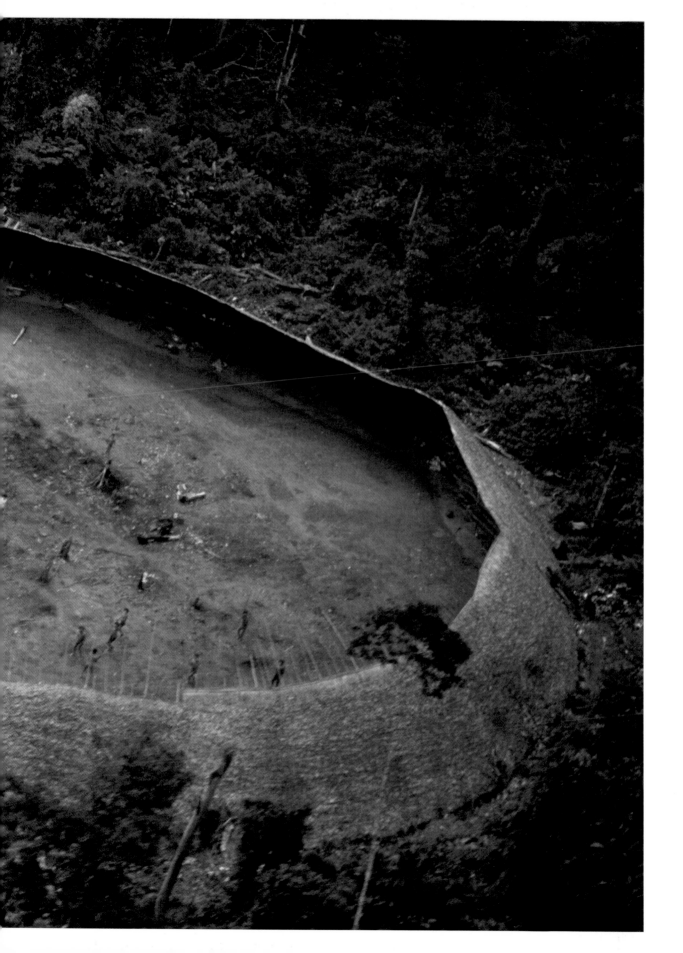

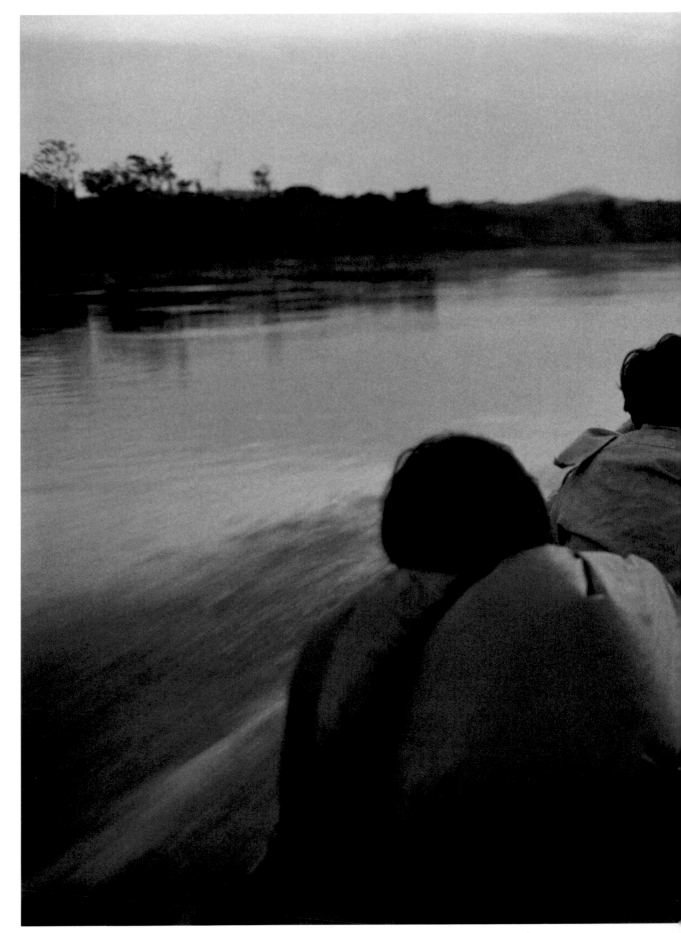

Upper Orinoco River,
Boat expedition,
Venezuela, 1996

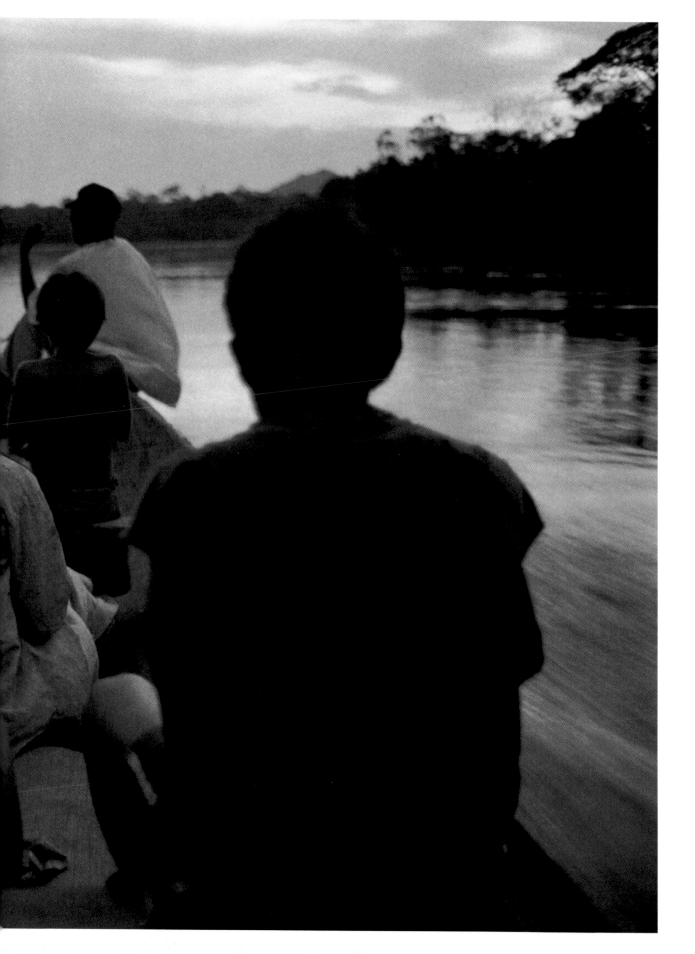

*Our land, our forest will only die off if the white man destroys it. Then the streams will vanish, the earth will become parched, the trees will dry up, and the rocks of the mountains will split with the heat. The xapiripë spirits who live on the mountains and play in the forest will run away. Their fathers, the shamans, will no longer be able to call them to protect us. The land-forest will become dry and empty. The shamans will no longer be able to deter the smoke-epidemics and the evil beings who make us fall sick. Thus, all will die.*

–Davi Kopenawa Yanomami, Shaman

Translated by Bruce Albert, Anthropologist IRD (Institut de Recherche pour le Développement)

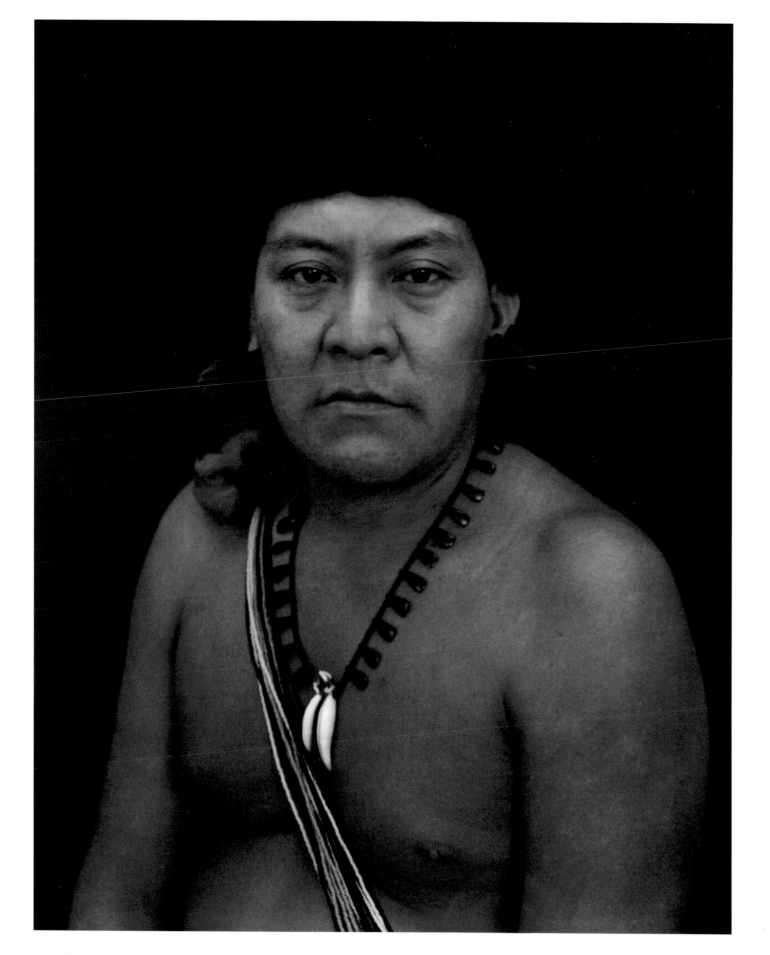

# Author's Note

by Valdir Cruz

During the fall of 1994, I met and photographed Davi Kopenawa Yanomami, a shaman and the headman of Demini-teri, a Yanomami village in northern Brazil near the Venezuelan border. He had come to New York to deliver a message at the United Nations concerning the plight of the indigenous people of the Brazilian rainforest. For me his message was a wake-up call concerning the people of my country.

At that point, I had been living away from Brazil for more than 15 years, and was shocked to learn that the indigenous people were suffering terribly from contact with illegal gold miners, loggers, professional hunters, and other outsiders. The diseases these people brought with them were decimating the Yanomami. With Davi Kopenawa's approval and help, I made a commitment to visit him and his people in Demini-teri. A year later I made my way from New York City to Caracas, Venezuela, the first of many steps of my journey.

From Caracas I journeyed two days by bus through the Brazilian frontier to the city of Boa Vista, capital of the state of Roraima and home of the Yanomami people. I arrived with my equipment and film, the names of three contacts I'd never met, and about eight hundred dollars in my pocket. After more than two weeks in Boa Vista dealing with bureaucracy, I finally reached Yanomami territory.

I enjoyed the next three weeks living with, observing and photographing the people of Demini-teri, but I soon surmised that I could be of more use. I returned to New York City

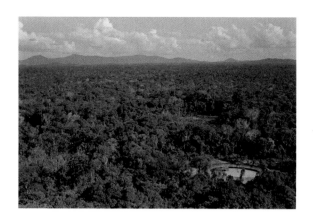

and applied for a grant from the John Simon Guggenheim Memorial Foundation, seeking a fellowship to support me in the work I proposed among the Yanomami. In April 1996, I learned that the images I had submitted from my first trip to Demini-teri had helped me in my candidacy. Now, as a Guggenheim Fellow, I was in a position to make an extended expedition in the land of the Yanomami.

On August 25, 1996, I returned to Caracas where I was to join the American writer Patrick Tierney, whom I'd met earlier that year in New York. Tierney was familiar with the conditions affecting the health and culture of the Yanomami in the Upper Orinoco River region of Venezuela. Knowing my work in photography and certainly of my interest in the Yanomami, Tierney had called me from Boa Vista several days earlier. Together, we set out from Caracas and proceeded to Puerto Ayacucho to meet Marinho de Souza, a Brazilian microscopist with much experience in treating the Yanomami, and whom Tierney had contacted in Brazil to accompany him on a long trek through the Siapa Highlands.

On August 28, the three of us took off in a four-seat, single-engine plane heading for the Kosharowa-teri settlement on the Upper Orinoco River. From there we traveled by boat until we reached Platanal, where we completed the necessary quarantine, and then set out on a trek to the Yanomami communities. The intention of this trip was to document reports of malaria and provide aid where and as we could by joining our efforts with those of the Salesian Missions, doctors of the

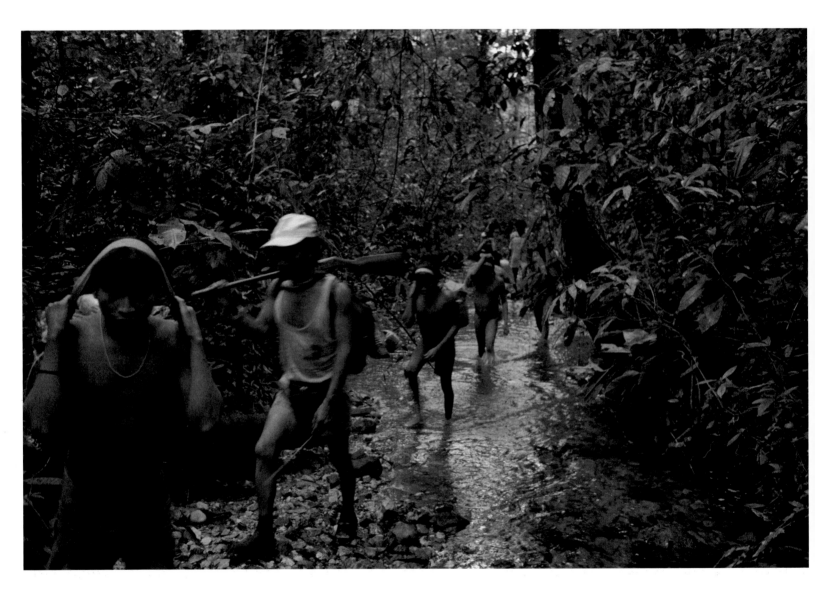

Alfredo Aherowe leading expedition through Siapa trail, Venezuela, 1996

Ministry of Health, and the Amazon Center for the Control and Investigation of Tropical Diseases (CAICET). Tierney principally focused on conducting a series of interviews with the dwellers of the Upper Orinoco Region for his book *Darkness in El Dorado*, a ten-year investigation concerning the devastation of Yanomami land.

From this experience, I was able to focus on my expedition to come. With the support of the National Health Foundation of Brazil, through their base in Boa Vista, I would accompany the microscopist Marinho de Souza, a nurse, and whenever available, a doctor who assessed the health of the Yanomami we met and distributed medicine to them in hopes of completing a medical report for the area. Whatever assistance I could bring would be my way of contributing something to the welfare of the Yanomami, and I would produce a photographic document in the process. I then returned to New York City. In November 1996, after months of planning and preparation, I was ready for my third trip to the region, this time with partial funding by the Guggenheim Foundation, equipment provided by Leica Camera, and additional support from Kodak.

For the first part of this trip I traveled with Marinho. We stayed in Brazilian territory, and for three weeks visited the Yanomami area of Homoxi, Therei-teri, where we encountered the saddest of the Yanomami people. Their region had been devastated by the gold rush of the late 1980s, and as a result of that unfortunate contact with the miners, the Yanomami had begun to neglect their traditions of food culture and to abandon other ancient customs. Important parts of their cultural identity eroded in the process, and fundamental belief systems were threatened. Those groups who had been most exposed to contact with the miners were in the gravest danger of losing all sense of their own identity and history. In what amounted to an insult to the historic dignity of these people, these outlanders left plastic sheeting behind, which the Yanomami then incorporated into the construction of their homes.

Marinho and I made our way back to Boa Vista, and by the second week of January 1997, we reached Caracas. We bought fresh provisions for the Venezuela trip: food, hammocks, fishing gear, gifts, ammunition, and fabric. We flew to Ocamo on the Upper Orinoco River and continued by boat to Platanal. There, we joined the Viennese nurse Claudia Kastinger of the Salesian Mission, who accompanied us on a trek inland toward the Siapa Highlands. By the end of March, we had visited nine communities and tested more than 300 Yanomami for malaria. About fifteen percent of the population were subsequently diagnosed with insect-born strains of malaria, a level considered low because of the relatively dry season. The epidemics would come with the rain.

Many months have passed since I last visited the Yanomami. I have made additional expeditions to the rainforest in the hope of registering other indigenous peoples in danger of acculturation, and have become familiar with the Makuxi, Ingariko, Yawanawa, Kaxinawa, Matis, and Korubos. From my experience, it seems clear that continued unrestricted contact with the natives of the rainforest can only lead to further cultural degradation. And the saddest part is that this is an irreversible loss.

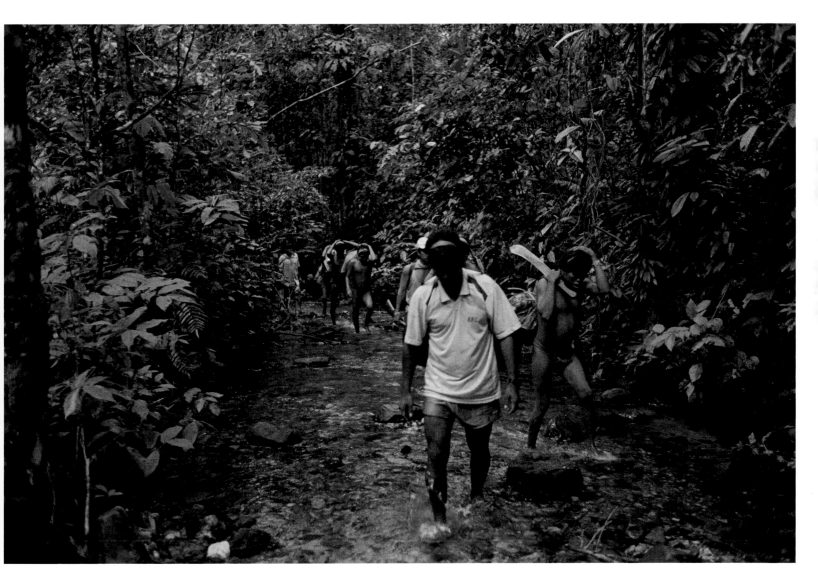

Marinho and Yanomami at the Siapa trail, Venezuela, 1996

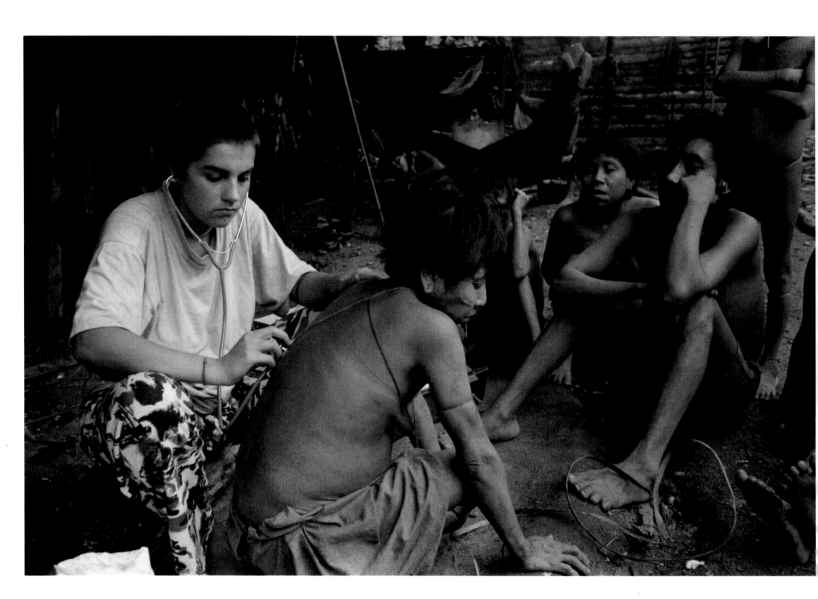

Claudia at work among the Yanomami, Venezuela, 1997

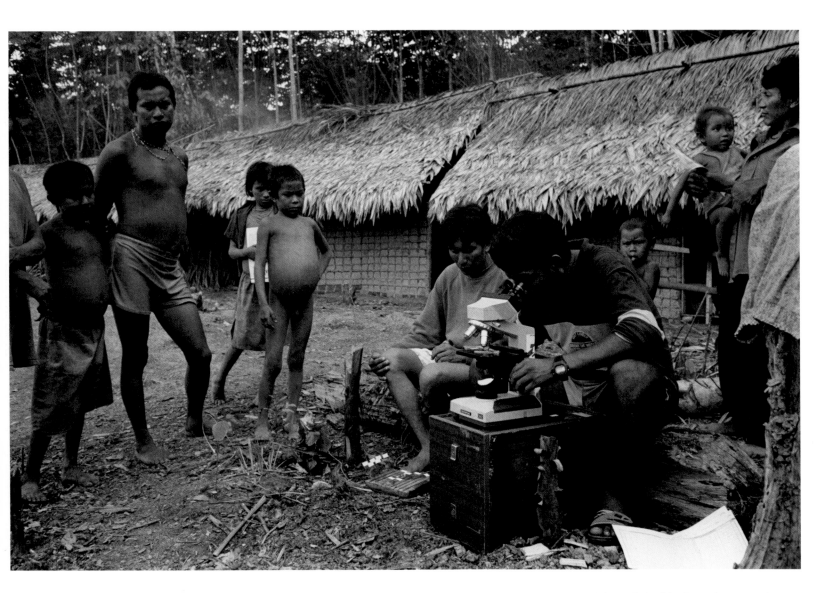

Marinho analyzing blood samples, Venezuela, 1996

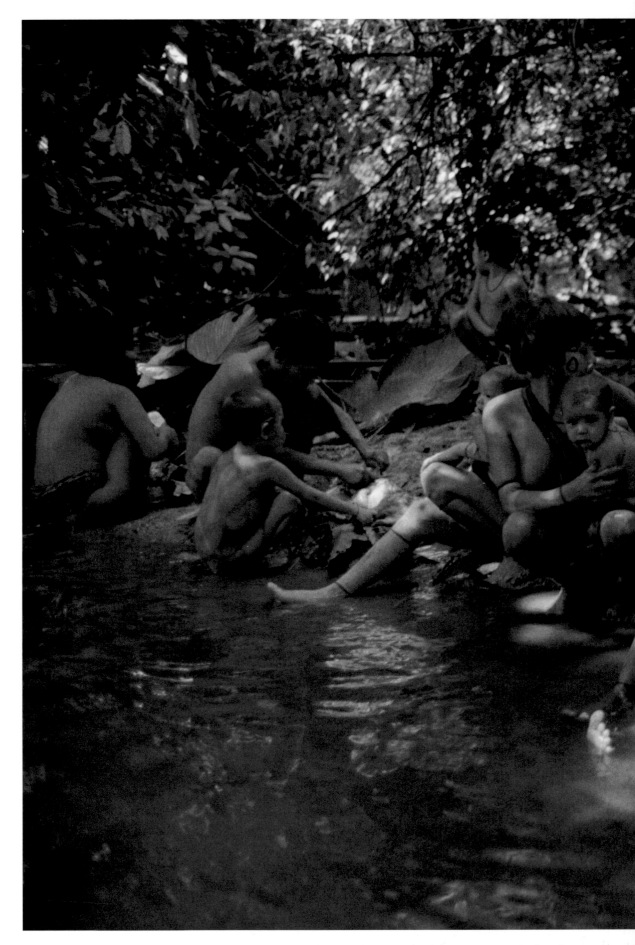

Yarima breast feeding among
her people, Venezuela, 1997

Following pages:
Girl from Irokai-teri,
Venezuela, 1997
Davi Kopenawa's daughter,
Brazil, 1995

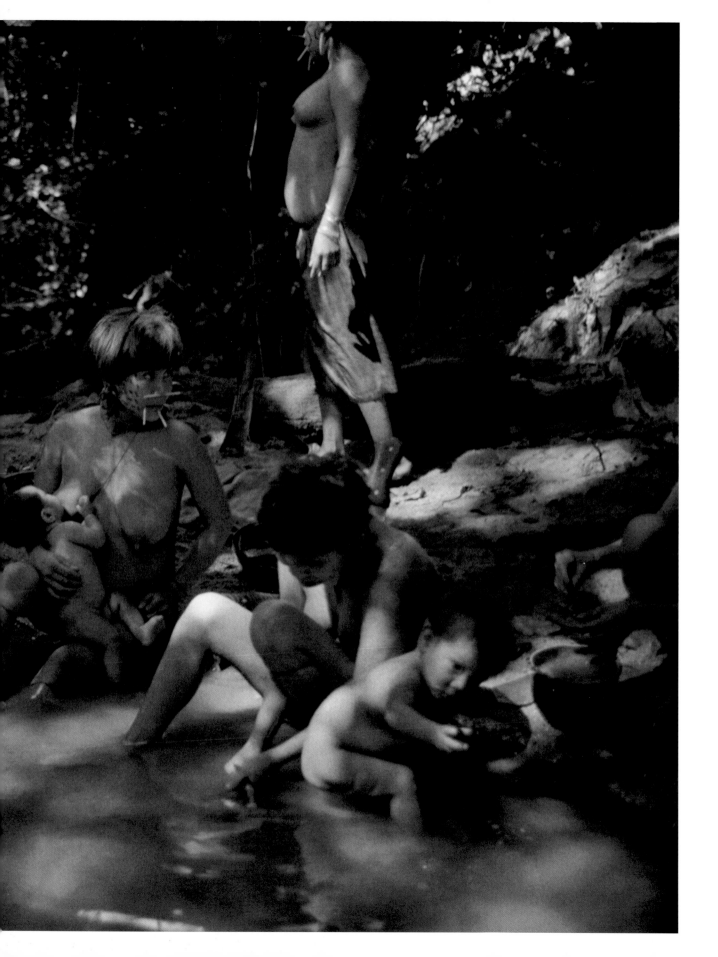

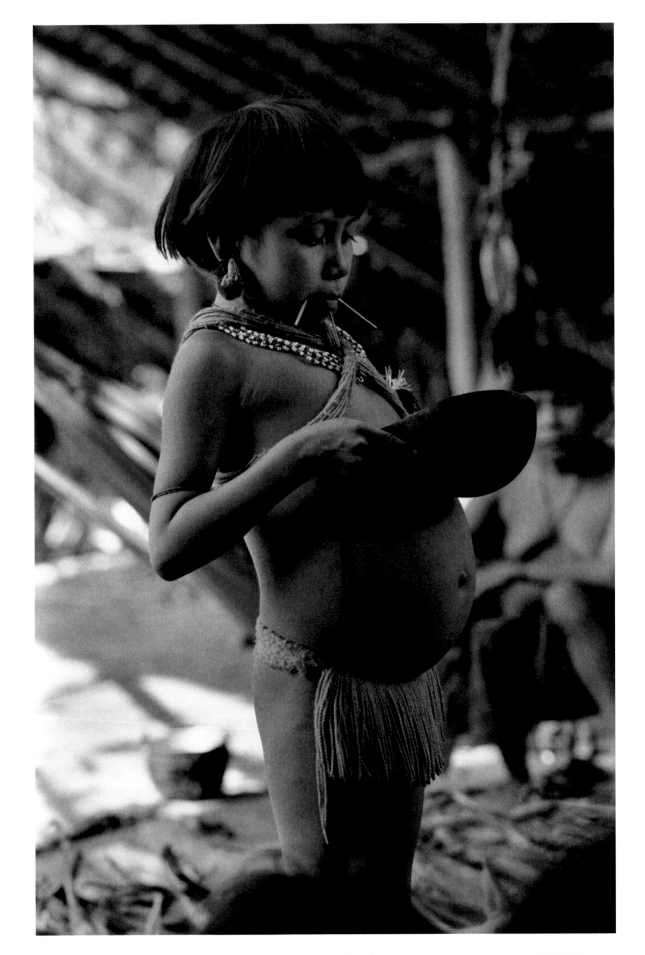

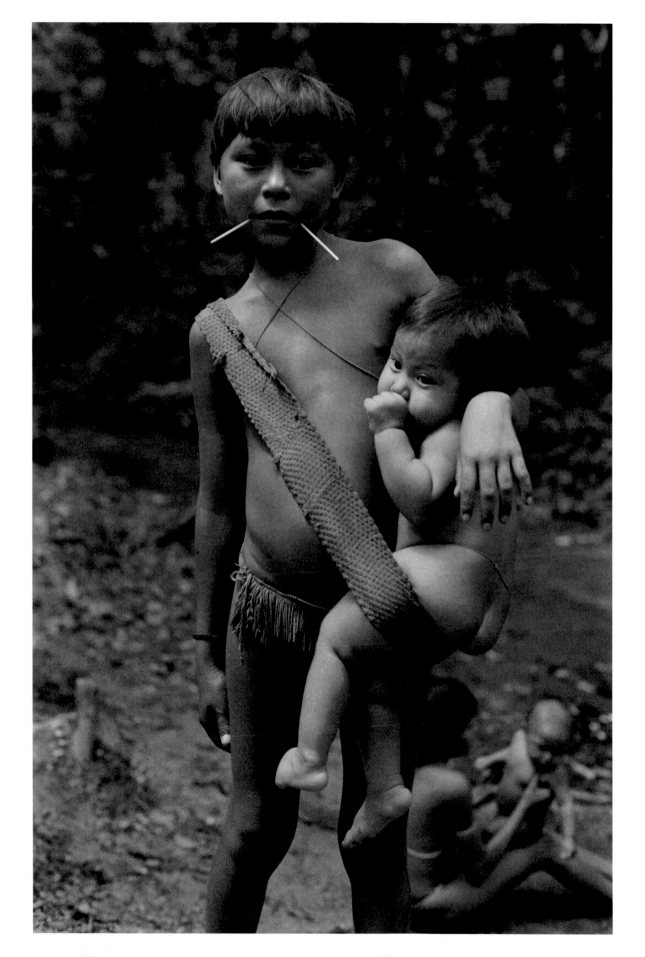

## September 6, 1996 — Venezuela

*This morning twelve of us set out on a trek from Hasupuwei-teri to Irokai-teri. Even though the porters transported all the heaviest bags and I carried only my equipment, the trail was difficult. The Yanomami walk in short, very fast steps that are a kind of running, and I was hard-pressed to keep up with them. Today I met Yarima, the Yanomami woman who was once married to the American anthropologist Kenneth Good. Yarima and Good had lived for a time in the United States and had three children. Her second husband, with whom she had a son, was killed in Yanomami warfare, and although Yarima had last been seen alive here in this community, many who live by the Orinoco River believe that she is dead. A very beautiful woman with a kind and strong spirit, she has remarried and is pregnant once again.*

*Towards afternoon, Yarima appeared in the village, returning from a day of hunting crab and gathering fruit. She told us how happy she is to have been able to return to her people, and I can't imagine her married to an outsider or living anywhere else but here. Although she disliked Pennsylvania and New Jersey, where she lived for a time with Kenneth Good, Yarima said that if she'd had a Yanomami companion with her she might have considered staying longer. In any case, she agreed to let me photograph her, and the women of the village helped her prepare for the portrait, trimming her hair and painting her face and body. I started photographing her in the village, and then finished at a nearby pond where dappled light filtered through the dense forest trees.*

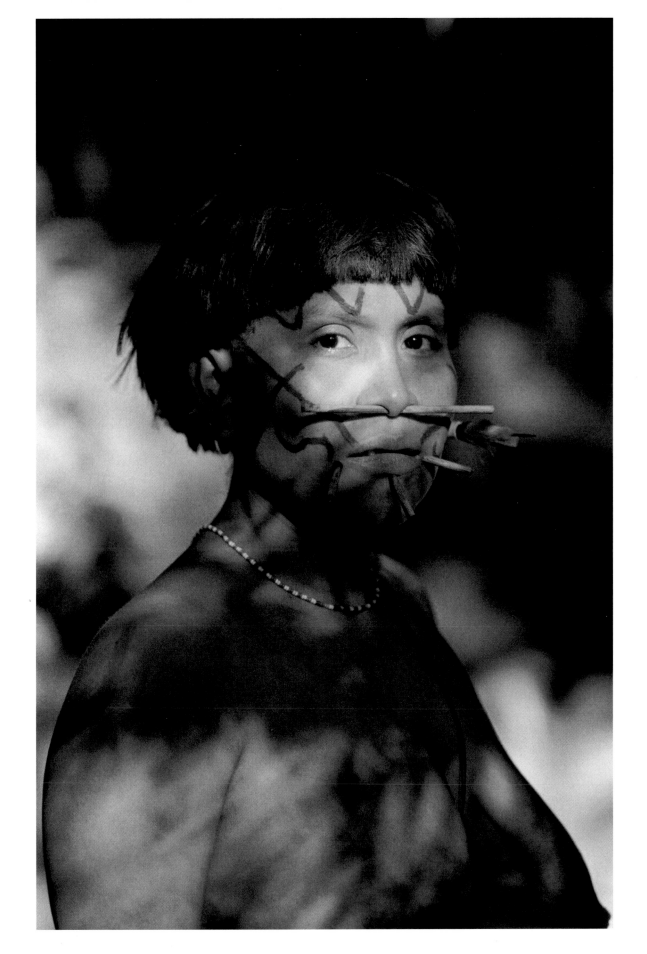

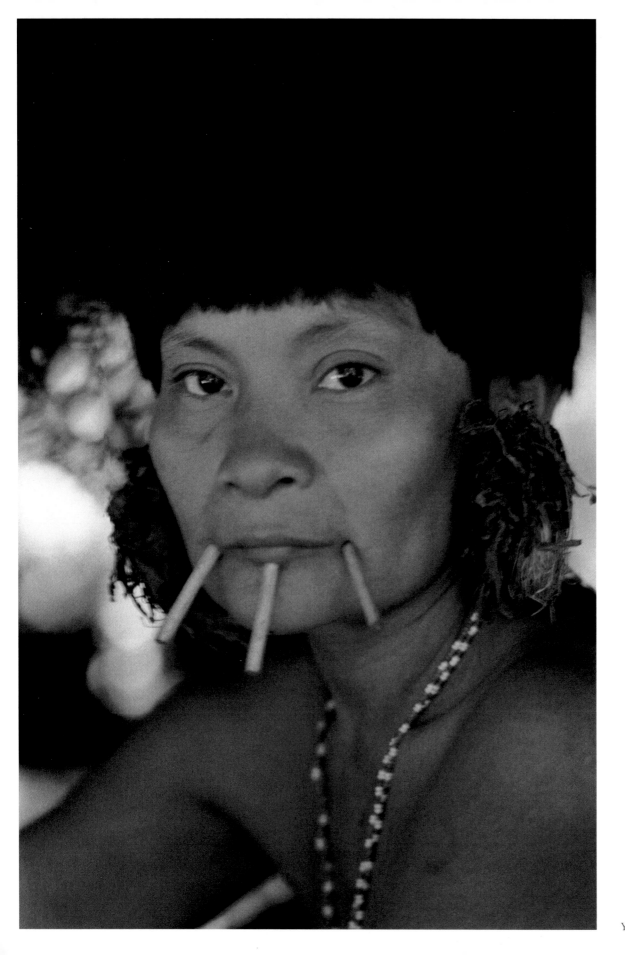

Yanomami wife, Venezuela, 1996

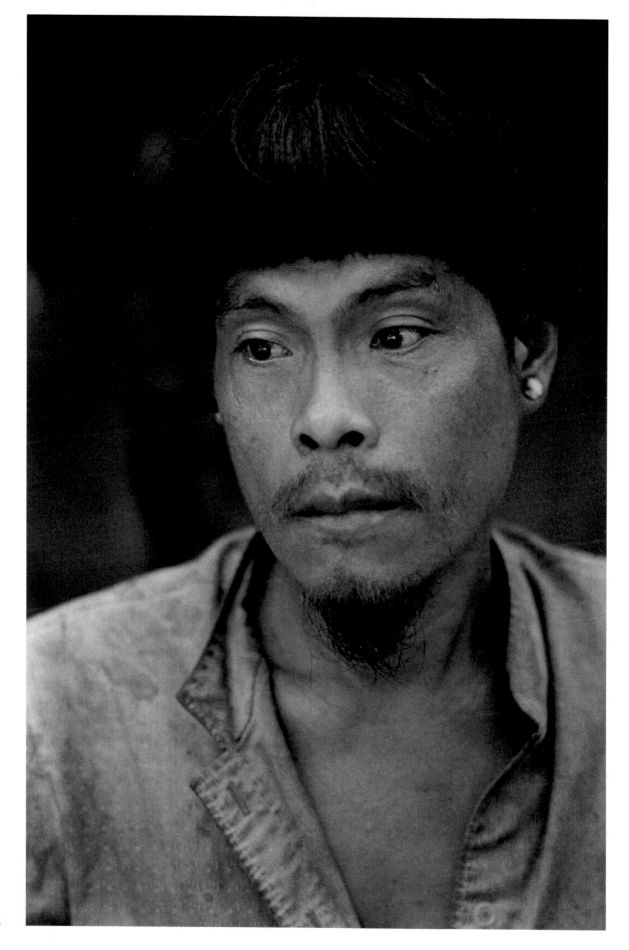

Yanomami husband, Venezuela, 1996

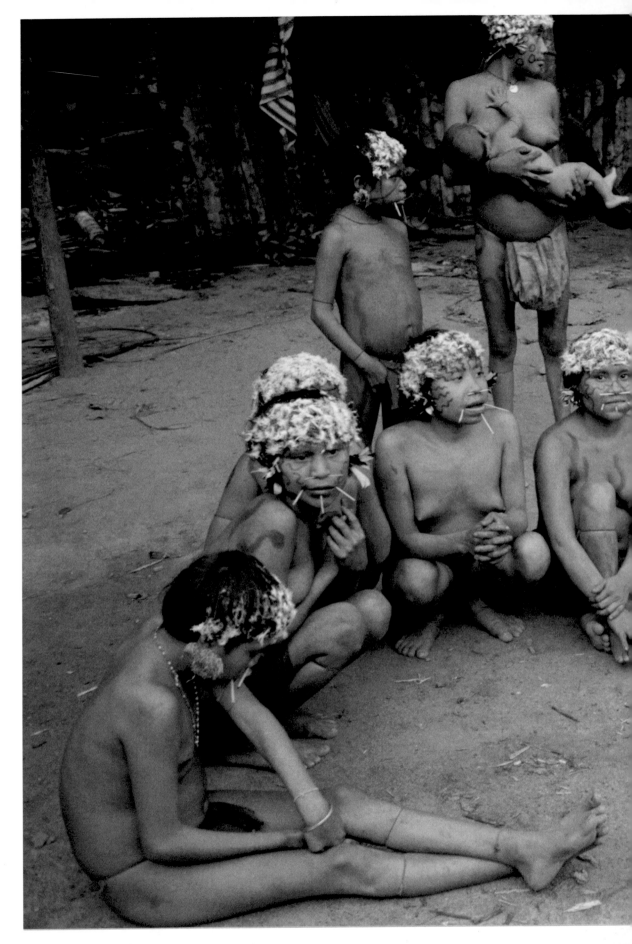

Afternoon gathering,
Venezuela, 1997

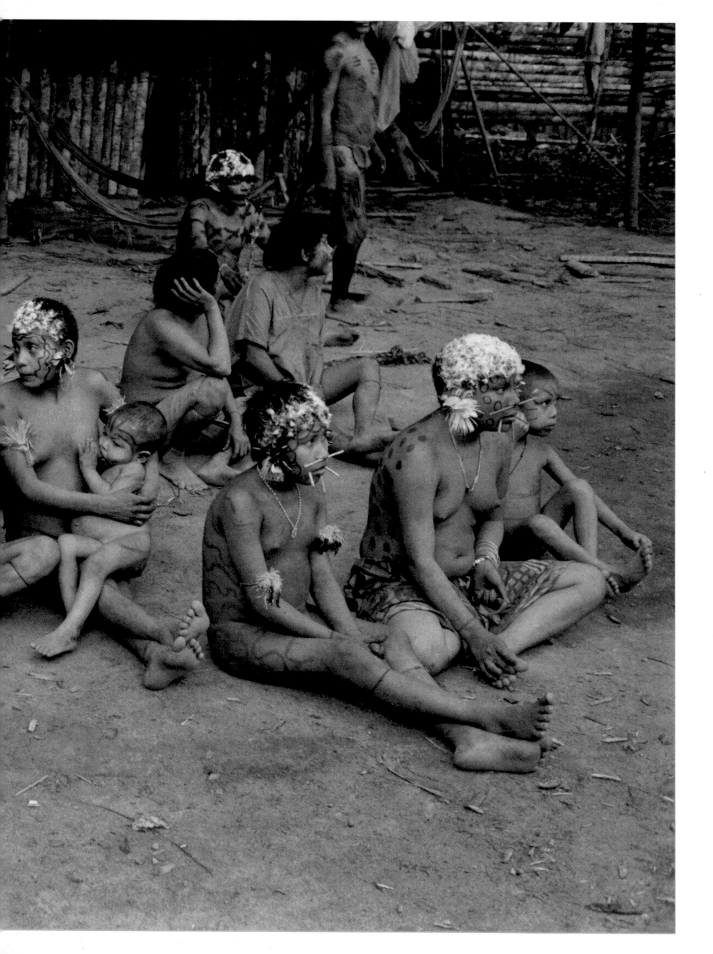

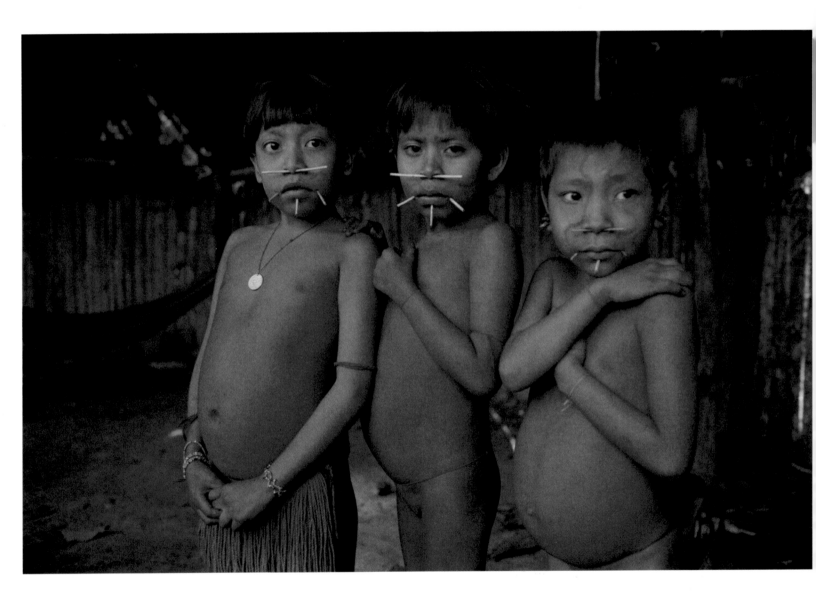

Female children, Venezuela, 1997

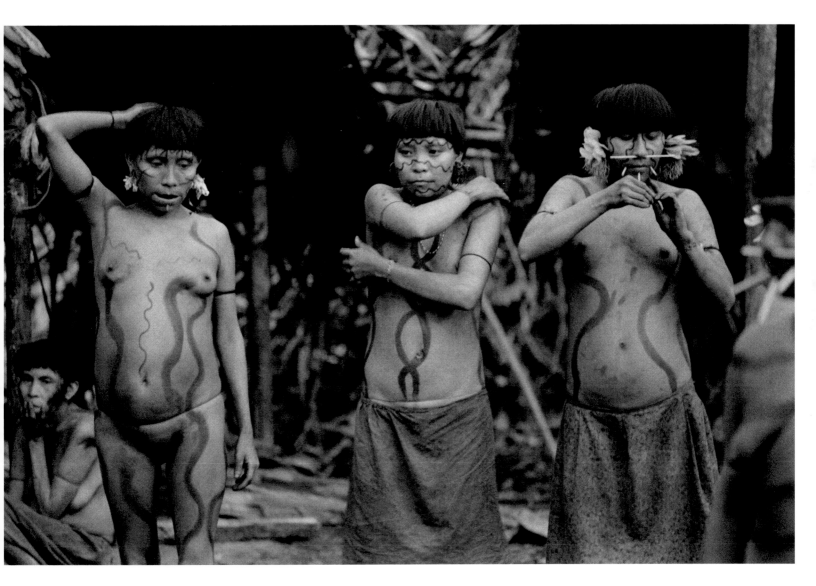

Female adults, Venezuela, 1997

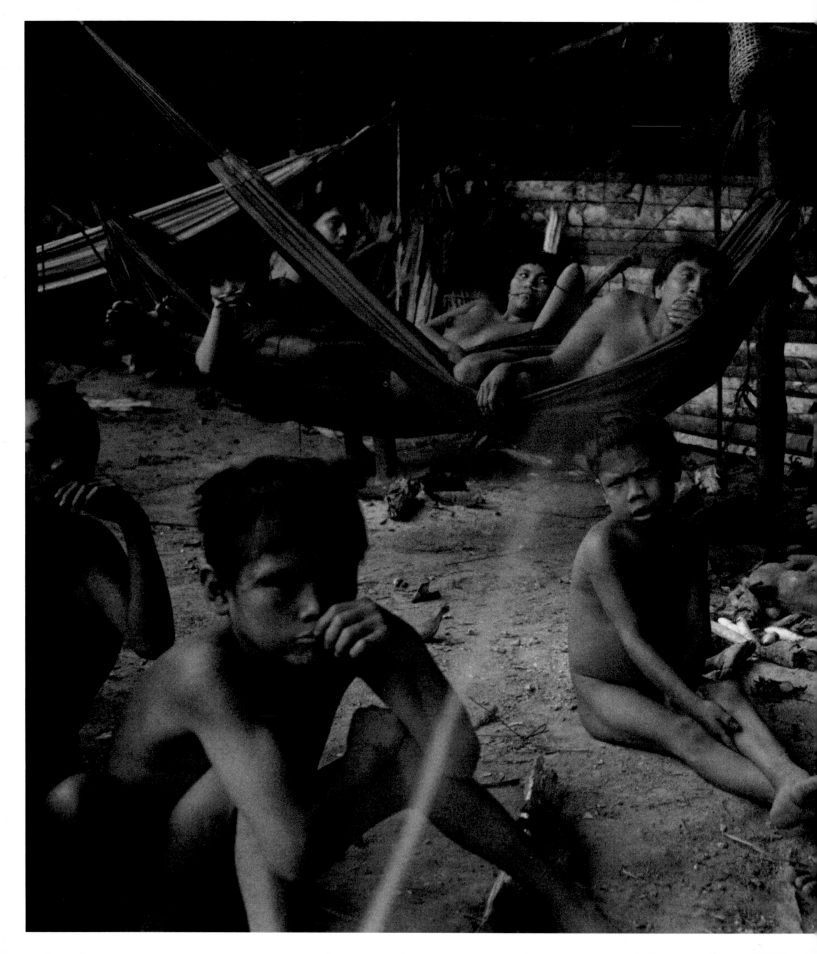

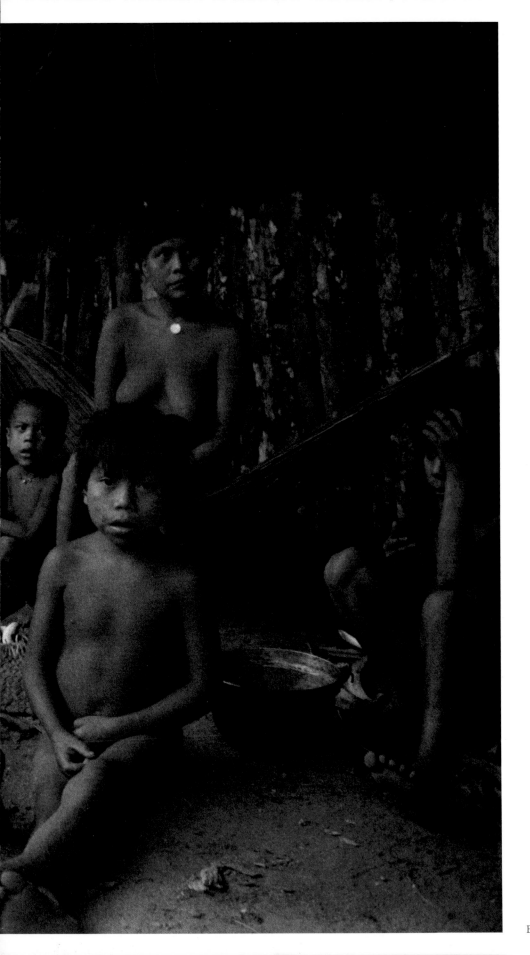

Early morning at Mokarita-teri, Venezuela, 1997

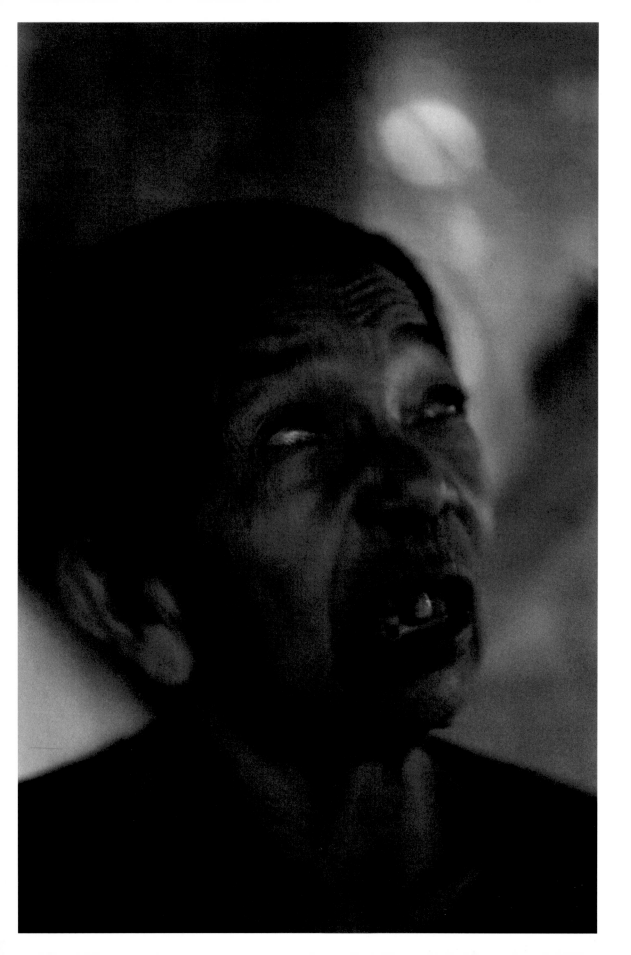

## August 31, 1996 — Venezuela

*This morning, we took off in a bongo, a dugout canoe made from a tree trunk with an outboard motor attached, and made our way to Mavaca on the Upper Orinoco River. There were eight of us on board, with our equipment, food reserves, gifts, and medicine. We traveled by daylight, making short stops so that we could visit a few people along the way and I could make some acquaintances. I met a Brazilian woman, Helena Valero, whose life with the Yanomami is described by the Italian anthropologist Ettore Biocca in his book, Yanoáma. I learned that in 1932, when Helena was eleven or so, she and her parents had traveled up the Rio Negro on a hunting trip. They were attacked by the Yanomami warriors of Kohoroshiwe-teri, who were armed with bows and arrows. Helena's parents were wounded and forced to leave her behind, where she grew up with the Yanomami who abducted her. In the months that followed, the Kohoroshiwe-teri were themselves attacked and dominated by the Yanomami of Karawe-teri, and Helena was once again taken prisoner.*

*Today, she told us that at the time of her first menses she ran away into the forest, where she lived by herself for nearly a year. She was eventually taken in by the Namoe-teri and married their headman, Fusiwe, who was regarded as a great warrior. They had two children. After Fusiwe was killed in tribal warfare, she married a man named Akawe, and with him she had two more children. Of her four children, two were killed in warfare. Akawe played an important part in getting Helena out of the forest, and helped reunite her with her parents, who were then living in Brazil. When her parents died, Helena returned to Venezuela. Completely blind with cataracts, she lived in extreme poverty by the Ocamo River until her death in February 2002.*

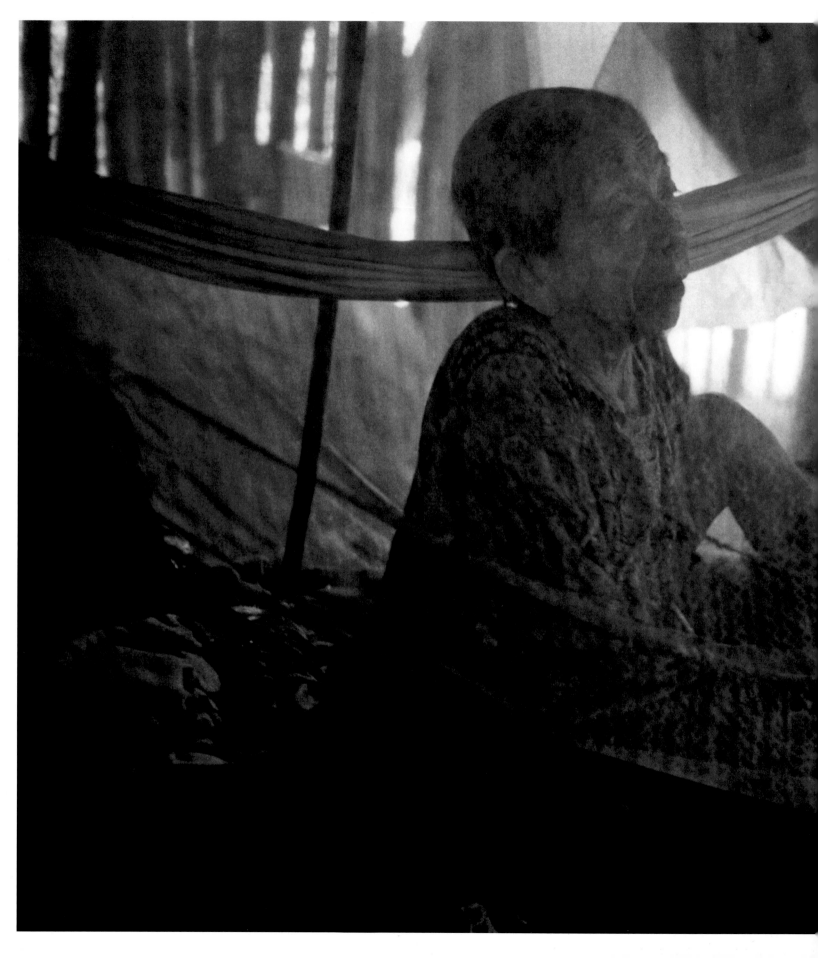

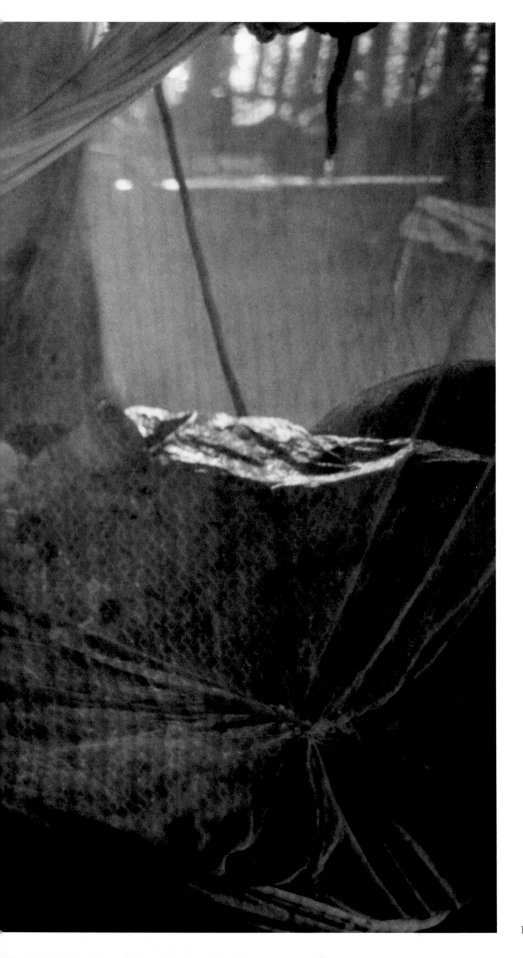

Helena Valero at home, Venezuela, 1996

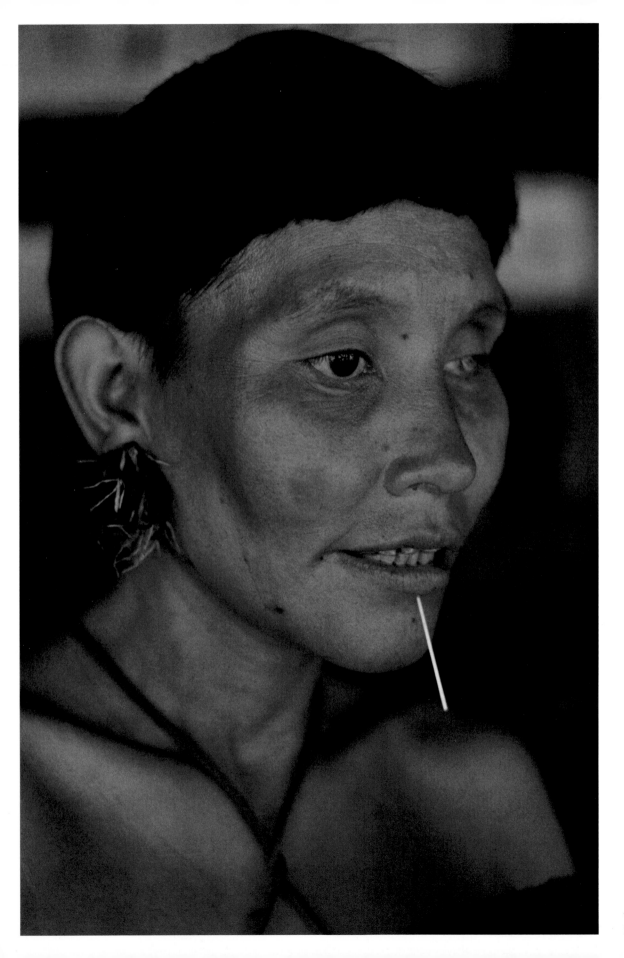

Woman with onchocirciassis,
Brazil, 1995

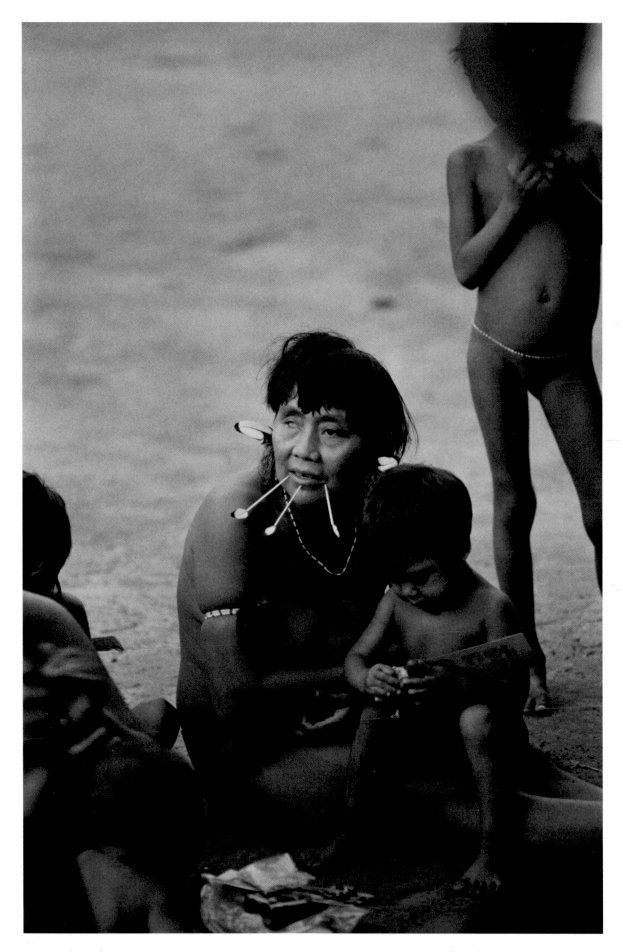

Woman with onchocirciassis and
her children, Brazil, 1995

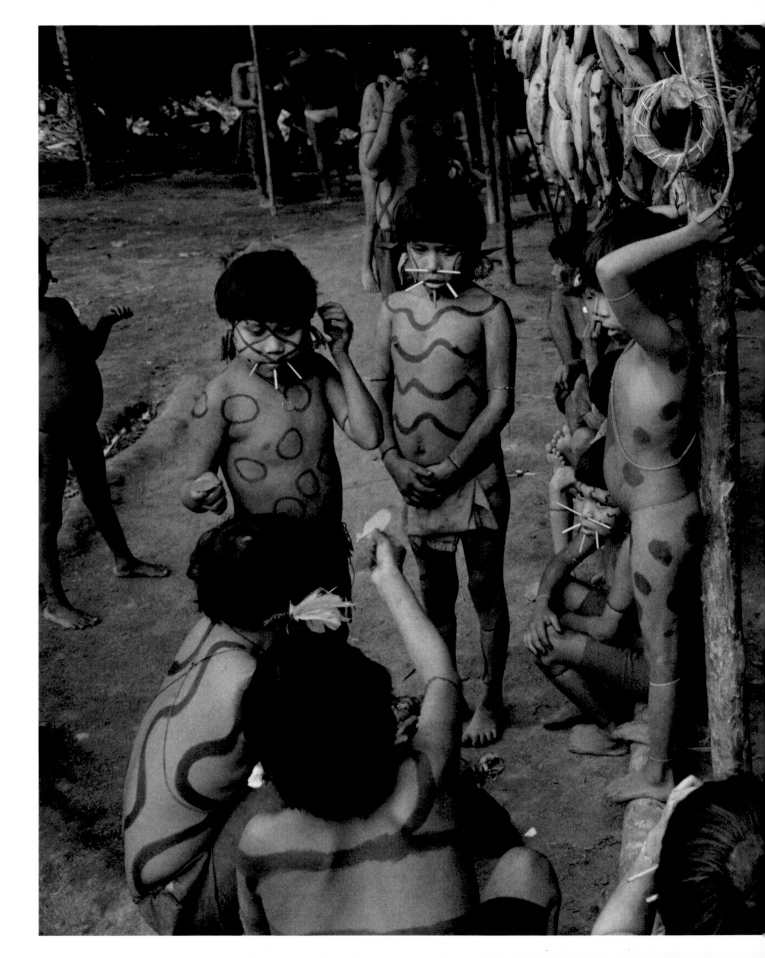

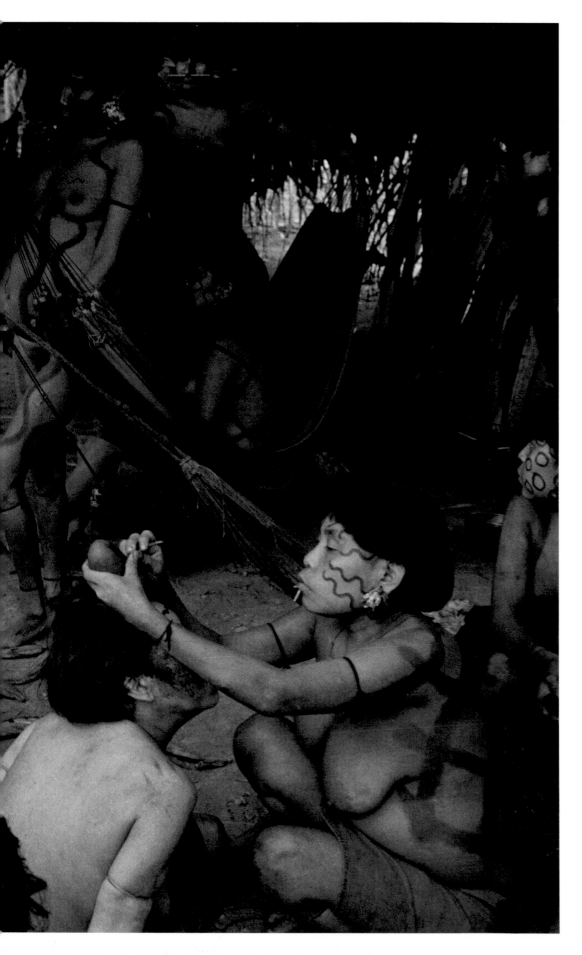

Preparing for an afternoon ritual dance,
Venezuela, 1997

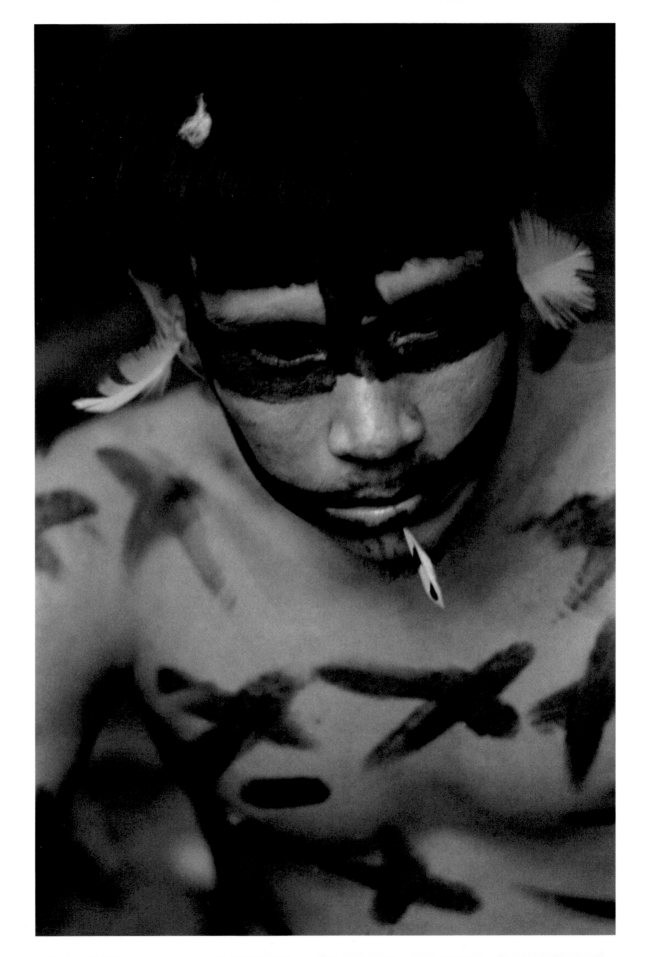

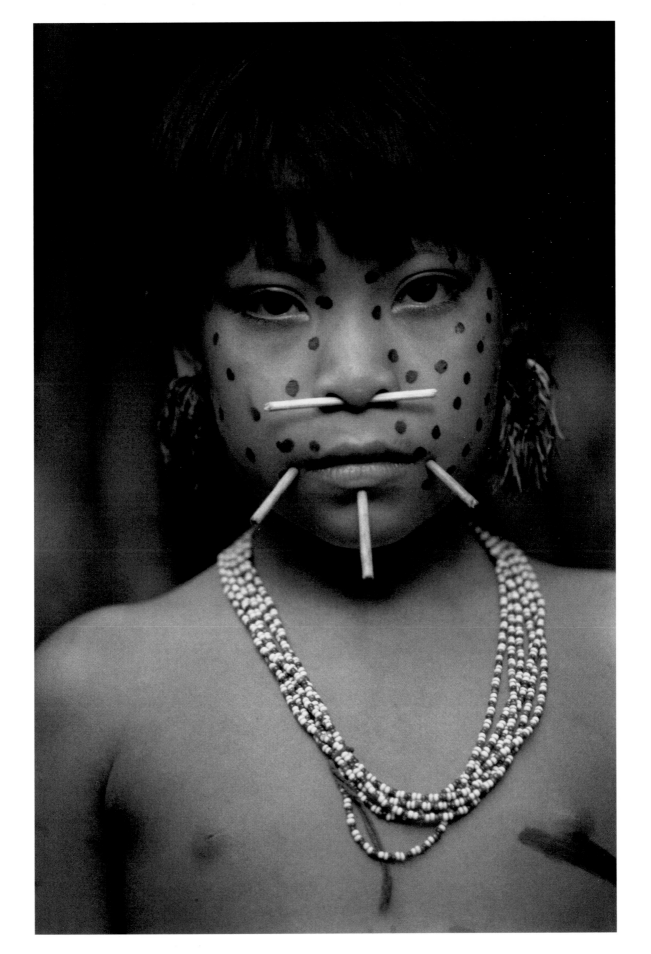

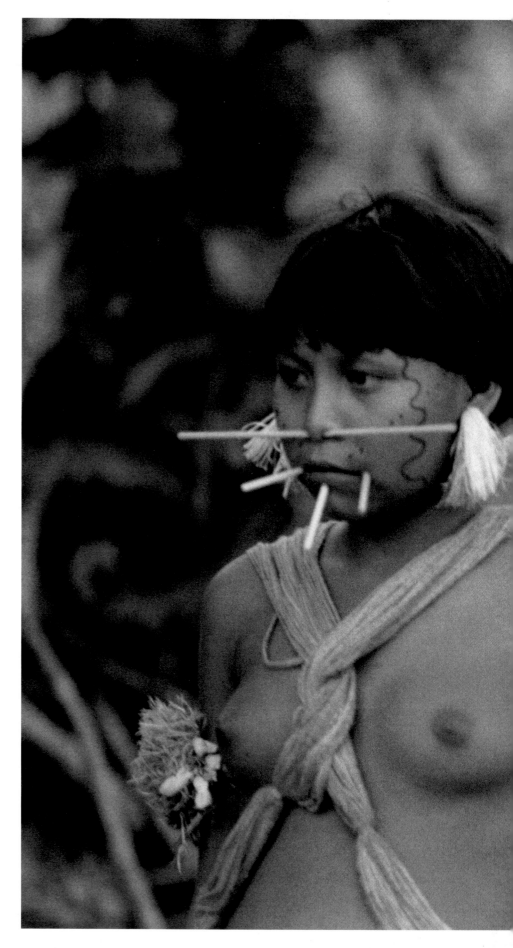

Previous pages:
Man with painted body and face, Venezuela, 1997
Girl from Mokarita-teri, Venezuela, 1997

Three young women, Venezuela, 1997

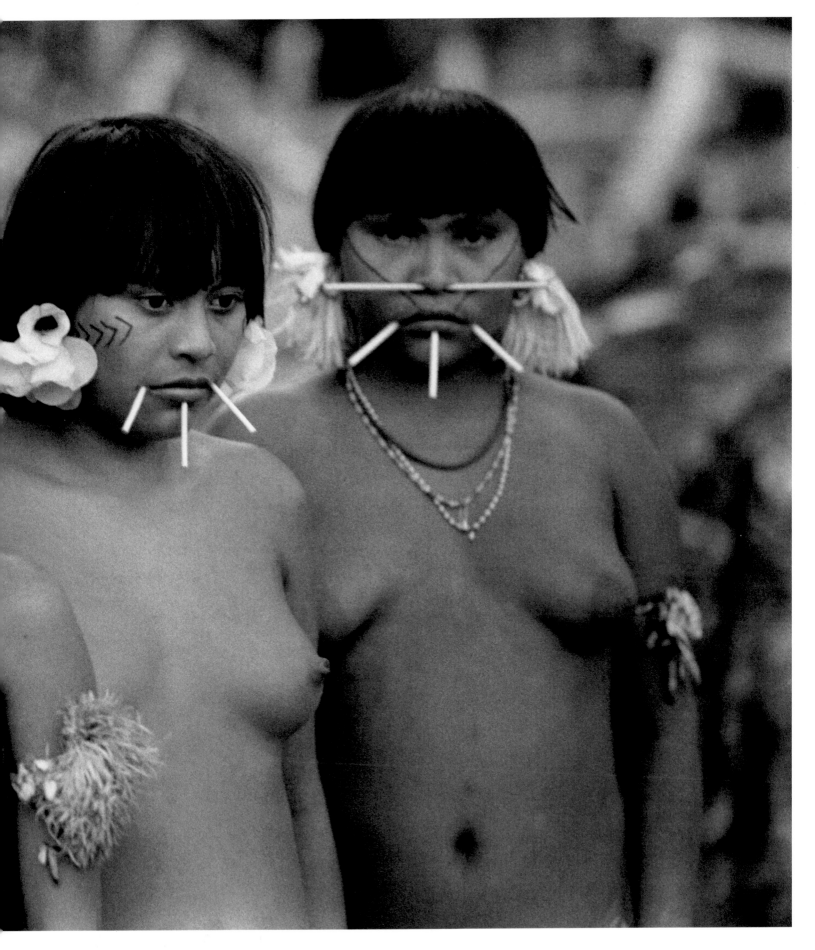

## September 2, 1996 — Venezuela

*When I asked Dimanawa if I could photograph him with all his wives, he didn't answer. After lunch he returned, adorned with feathers, and his wives painted themselves to prepare for the photograph. We gathered in a boat and went down the Mavaca River to the shapono where Dimanawa and his wives live. I thought the most important photograph from the afternoon would be of this group in the bongo near Dimanawa's shapono, with the woods behind them.*

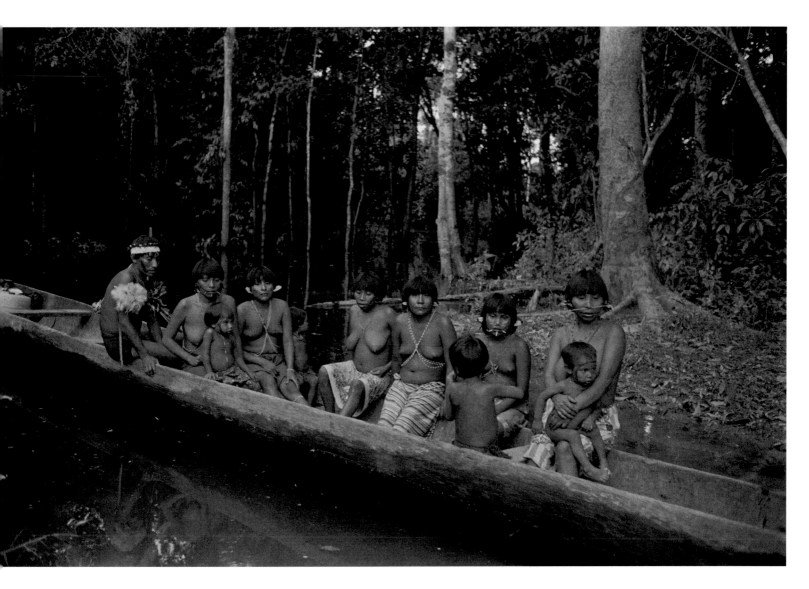

César Dimanawa and his wives, Venezuela, 1996

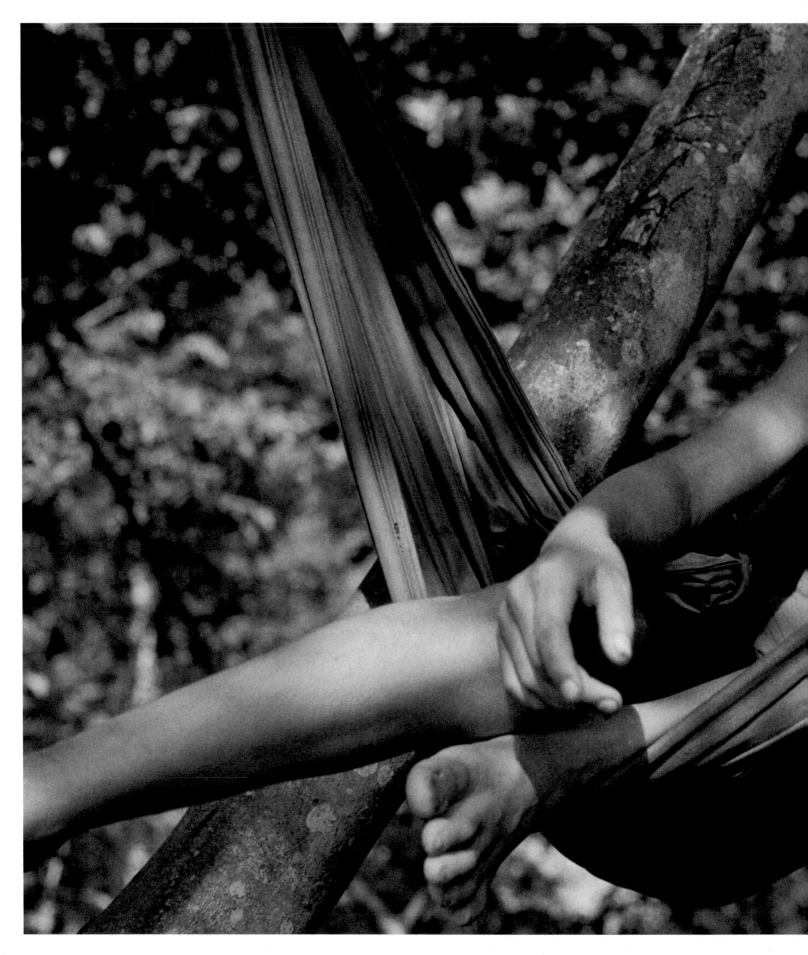

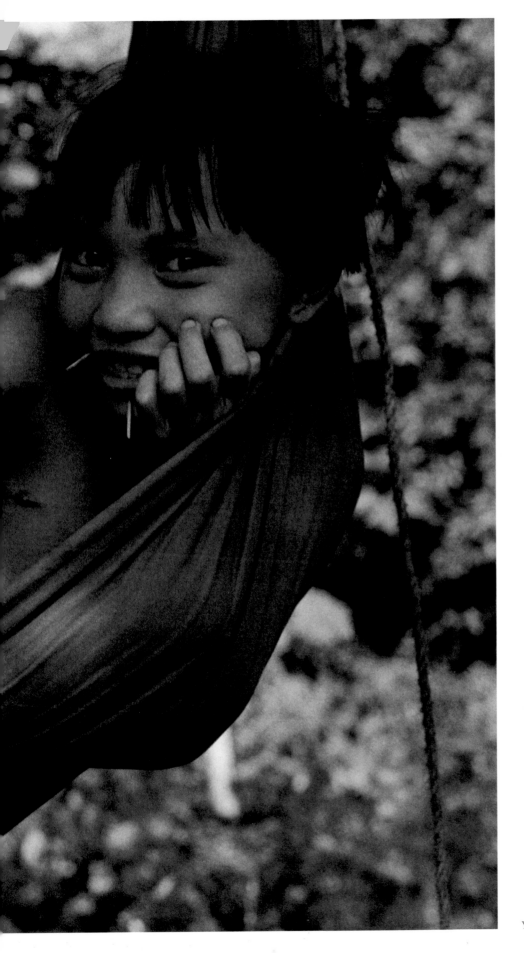

Yanomami girl playing in a hammock, Brazil, 1995

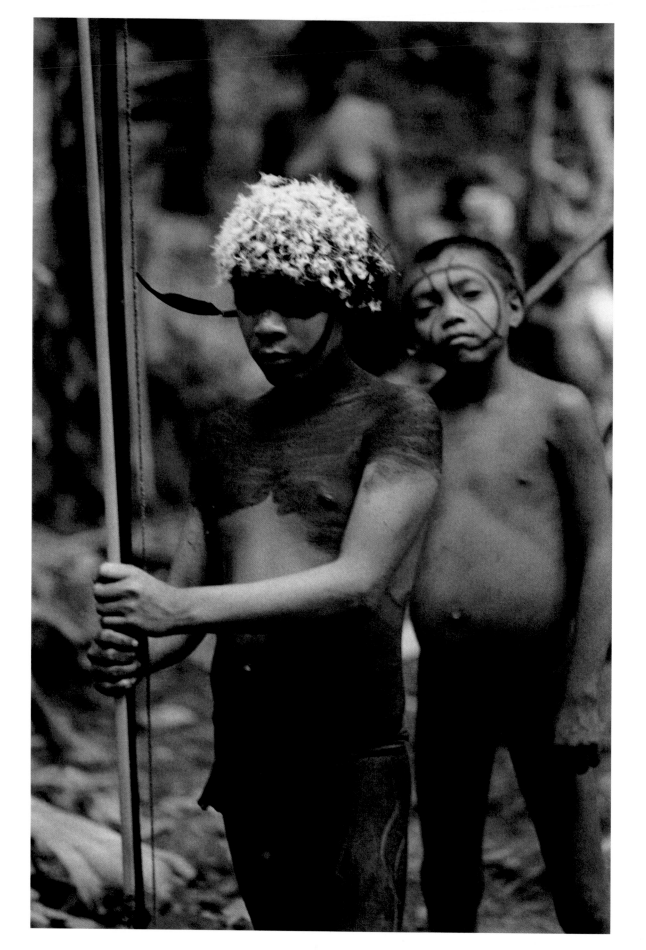

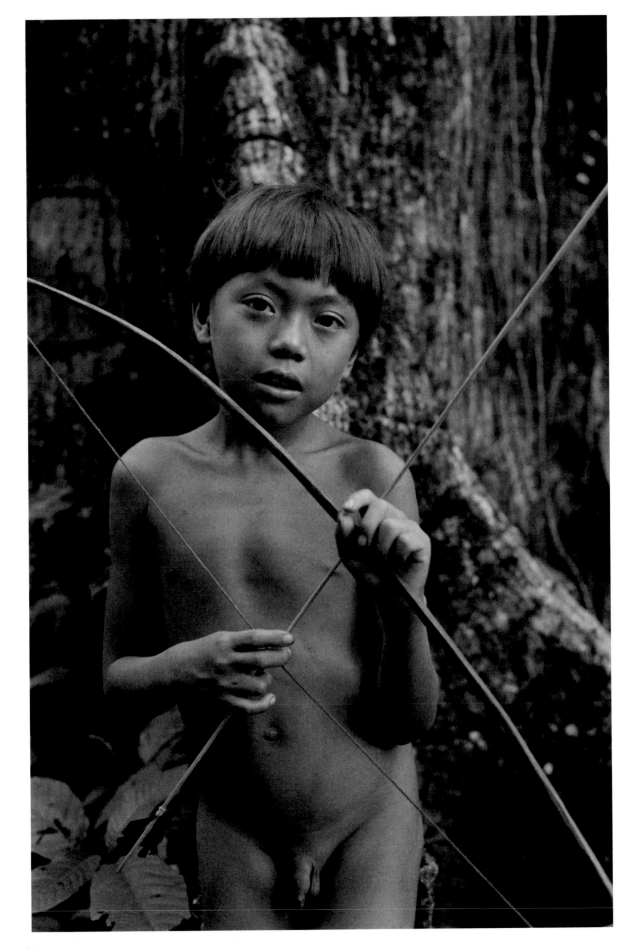

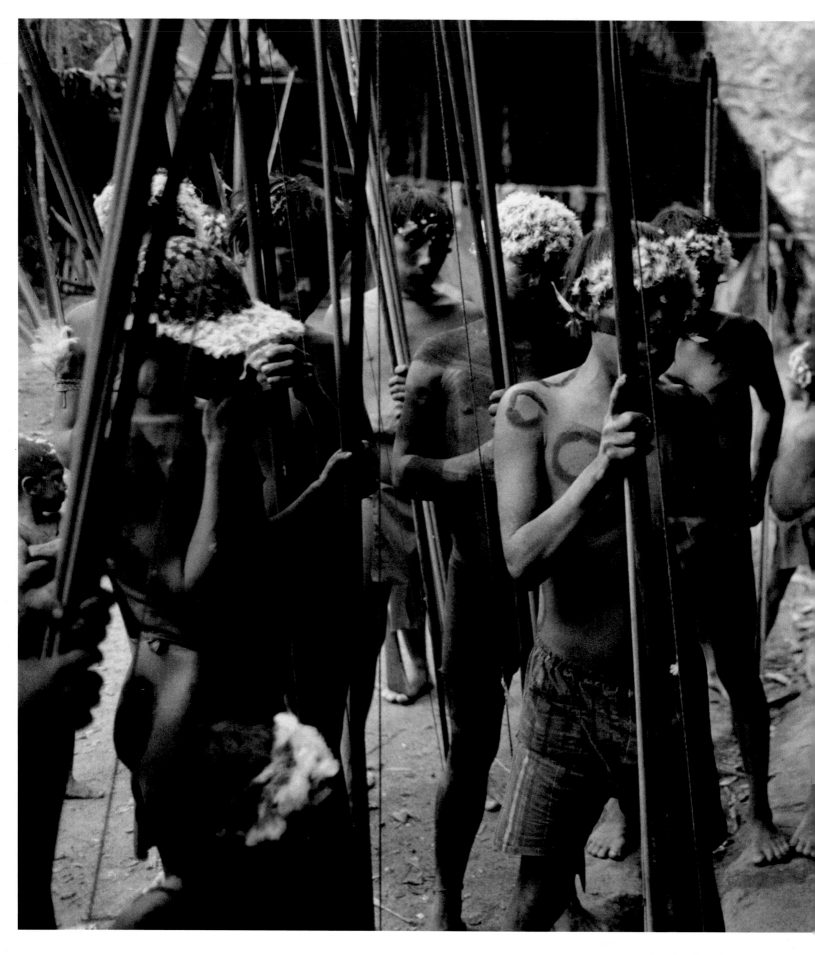

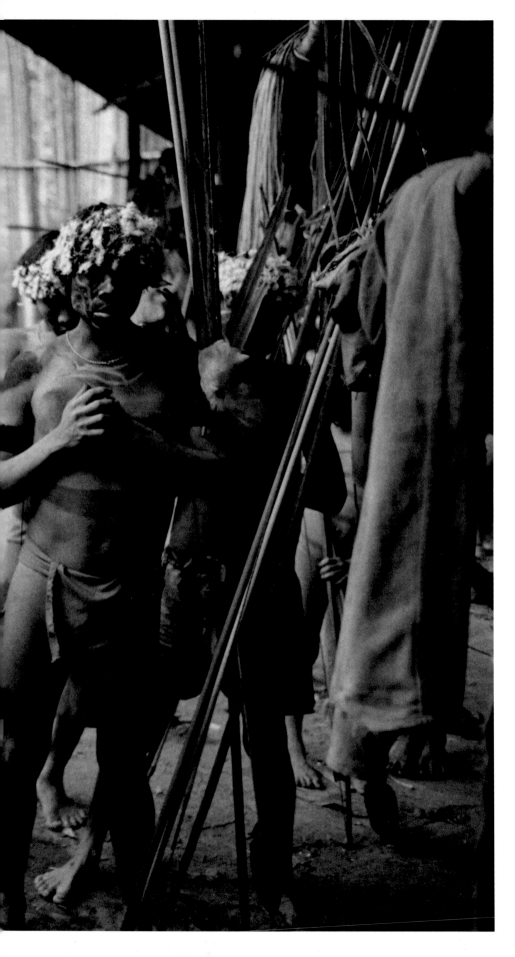

Previous pages:
Ready for the ceremony, Venezuela, 1997
Boy with bow and arrow, Brazil, 1995

Preparing for a ceremony, Venezuela, 1997

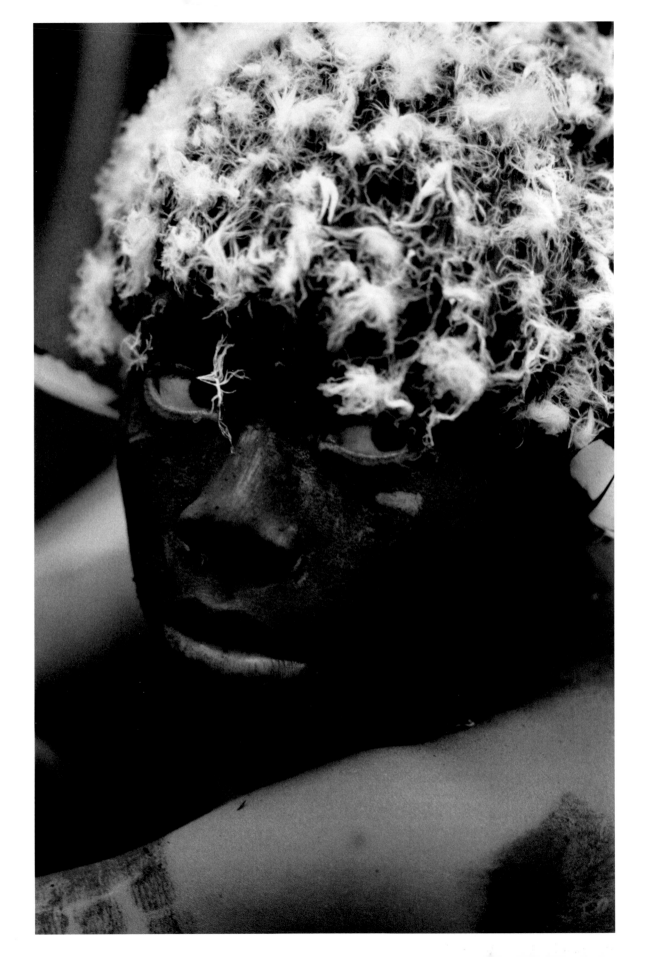

## February 16, 1997 — Venezuela

*Marinho has injured his leg and is attempting to return to the village of Irokai with Shoko, one of the porters. He offered me his shotgun, and I left him with enough supplies to last five days. Hopefully, he will travel slowly until he reaches Hasupewei-teri, or else he will wait for us wherever his legs can take him. Although neither Claudinha (Claudia) nor I can read the microscope slides, we continue to take blood samples to bring back to Platanal where Marinho can examine them. When the results are available, another group will come with the necessary medicine. Claudinha has taken fifty-six samples here in Mokarita.*

*This afternoon there was dancing. The men came into the shapono with painted bodies and buzzard feathers in their hair. They performed one by one, and then they made an entrance together, singing and dancing. I observed a ritual in which the immediate kin of someone who recently died mixed the ground powder of the relative's bones into a plantain drink and swallowed it. Some of the men helped me while I photographed the event, and at the end of the day I offered them what remained of my gifts.*

Man with painted face and buzzard feather, Venezuela, 1997

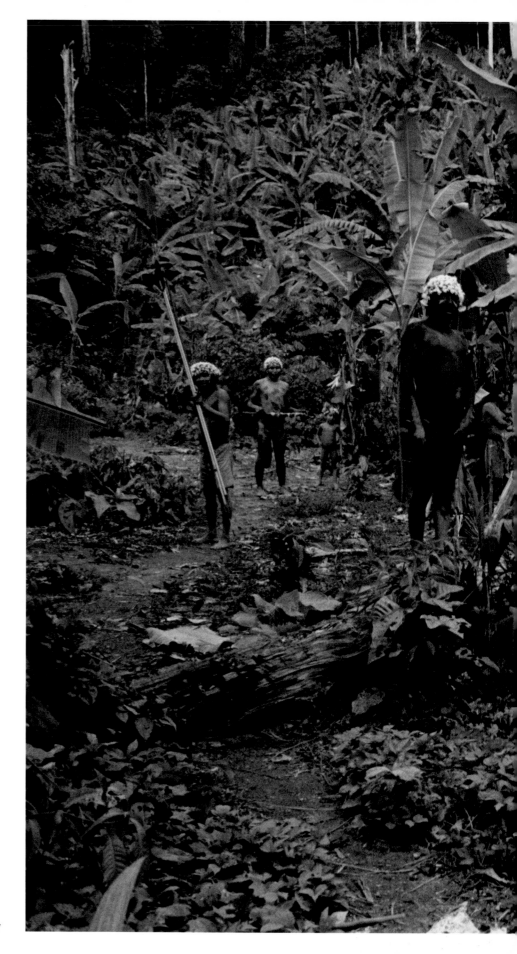

Yanomami at Mokarita-teri's garden, Venezuela, 1997

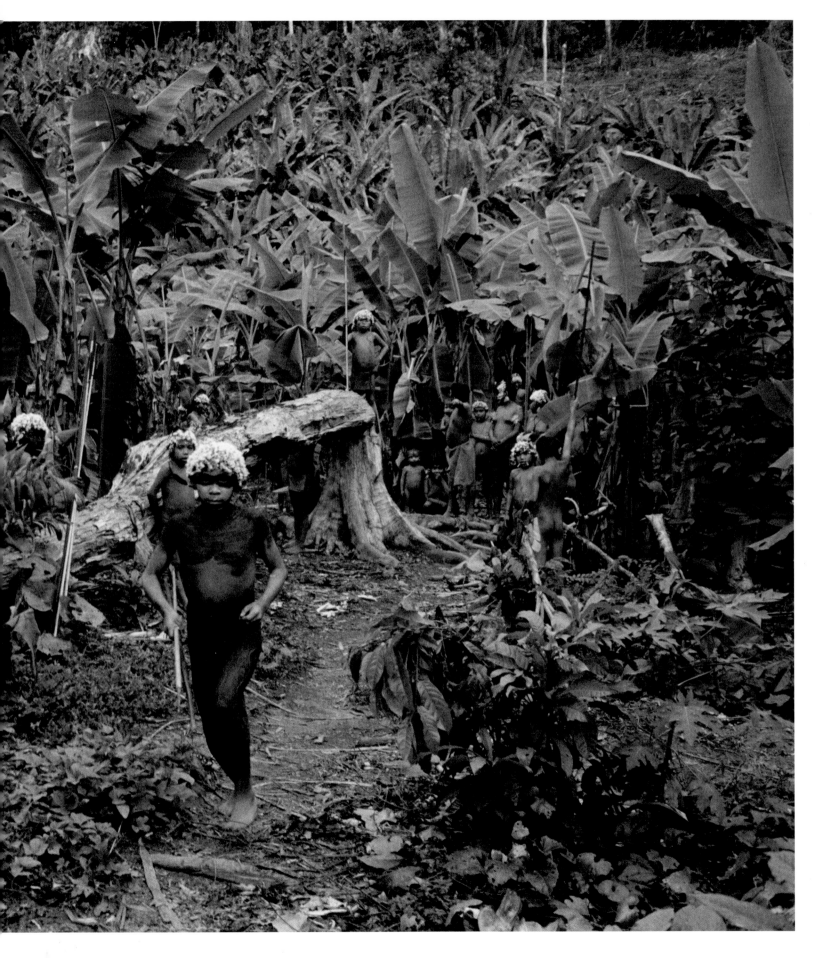

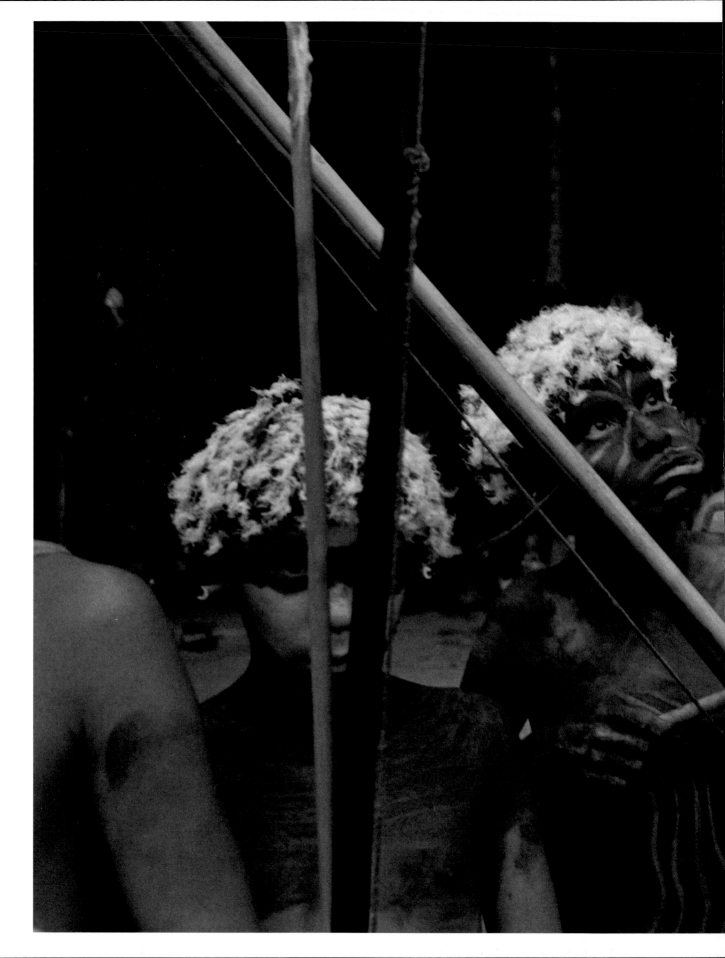

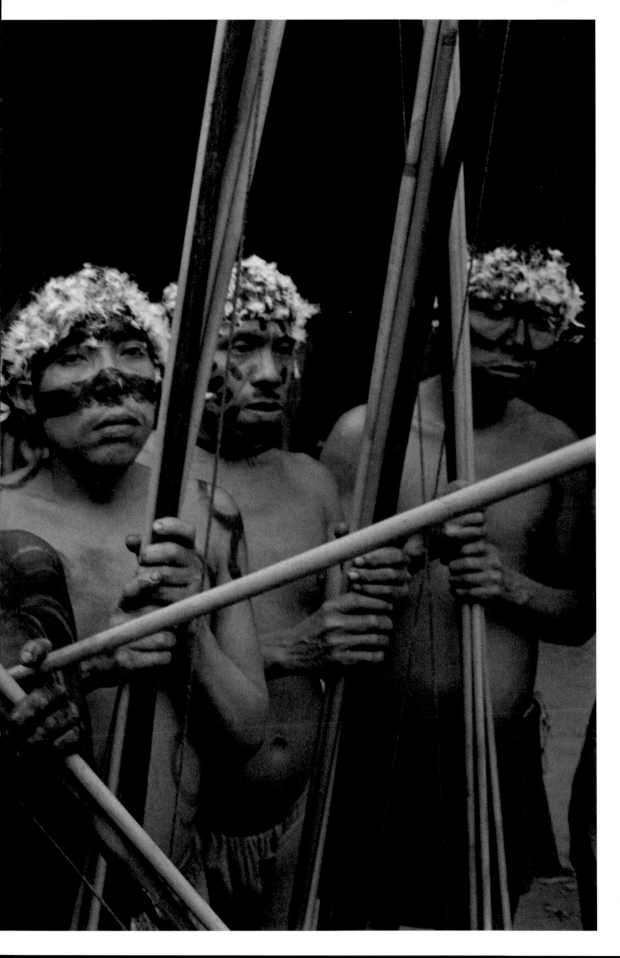

During a ceremony, Venezuela, 1997

Following pages:
Karakawe, Venezuela, 1996
Warrior with painted body, Brazil, 1996

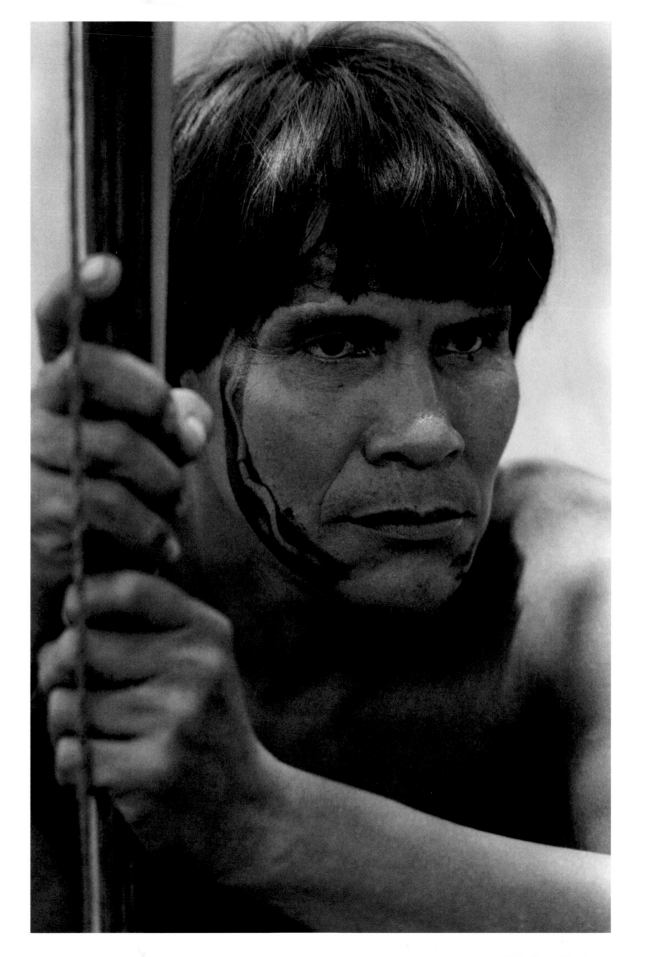

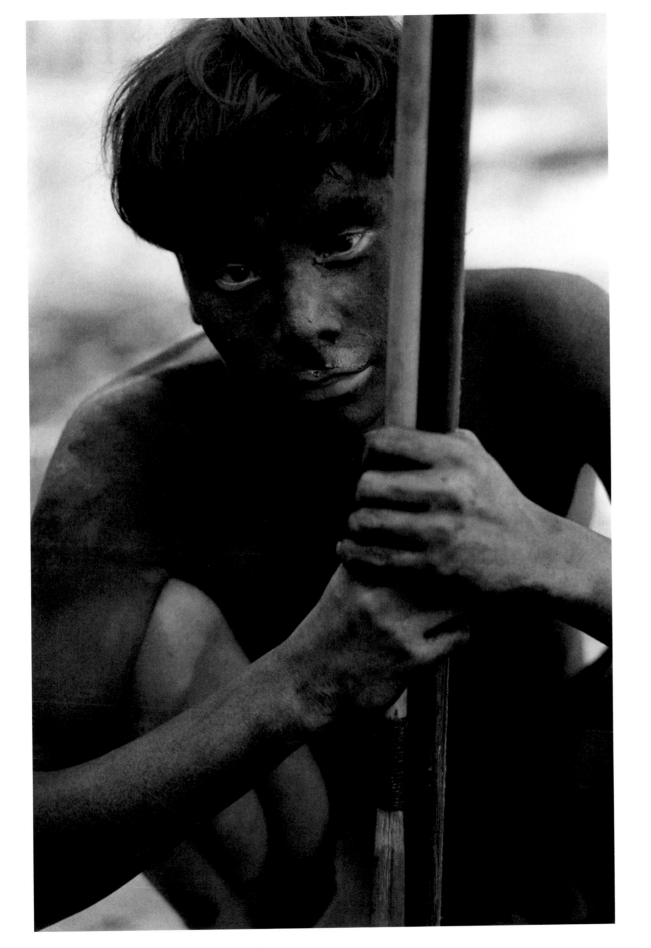

### September 2, 1996 — Venezuela

*We started today's journey at 3:30 a.m. under beautiful moonlight, and arrived in the village of Mavaquita*

*before noon. I wanted to meet the great, controversial leader César Dimanawa, who has six wives and is said*

*to have killed five men, all of them leaders of other communities. Although I thought he would be out hunting,*

*it turns out that the Yanomami who helped us dock our boat is the great leader himself. A quiet and sensible*

*man, he can't be more than forty.*

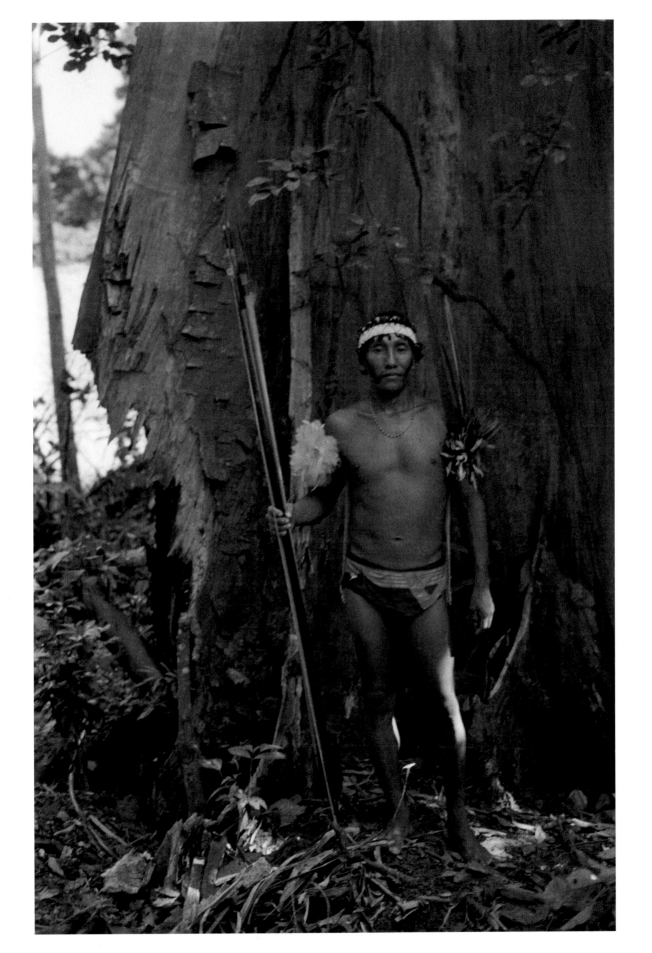

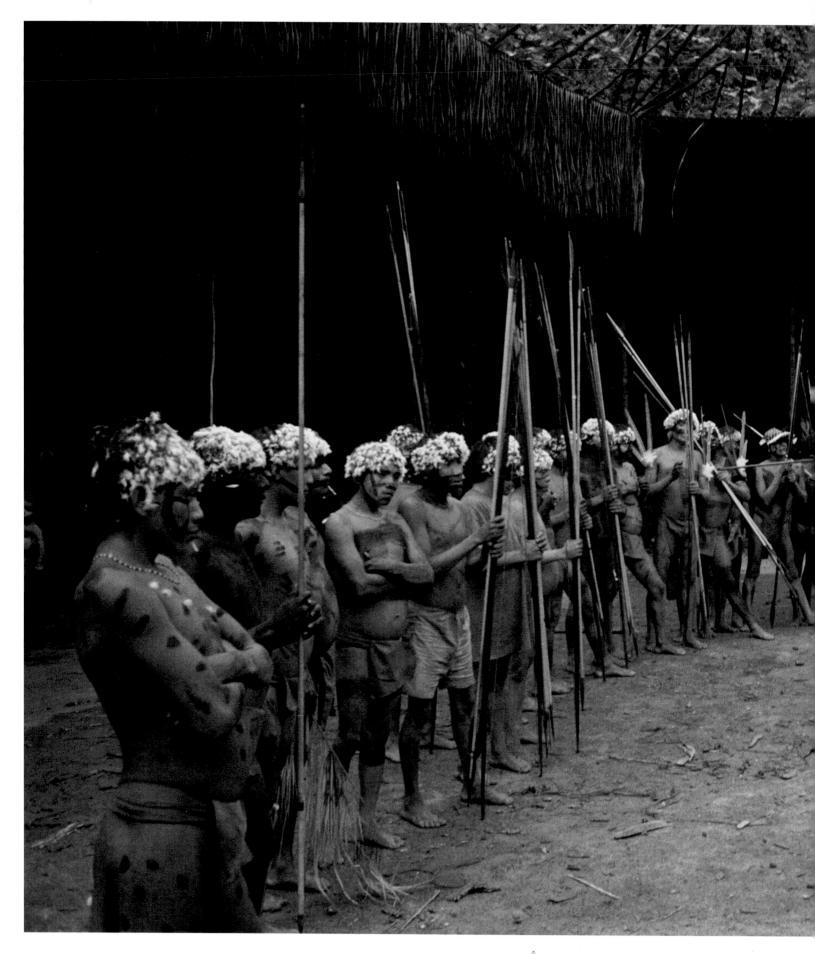

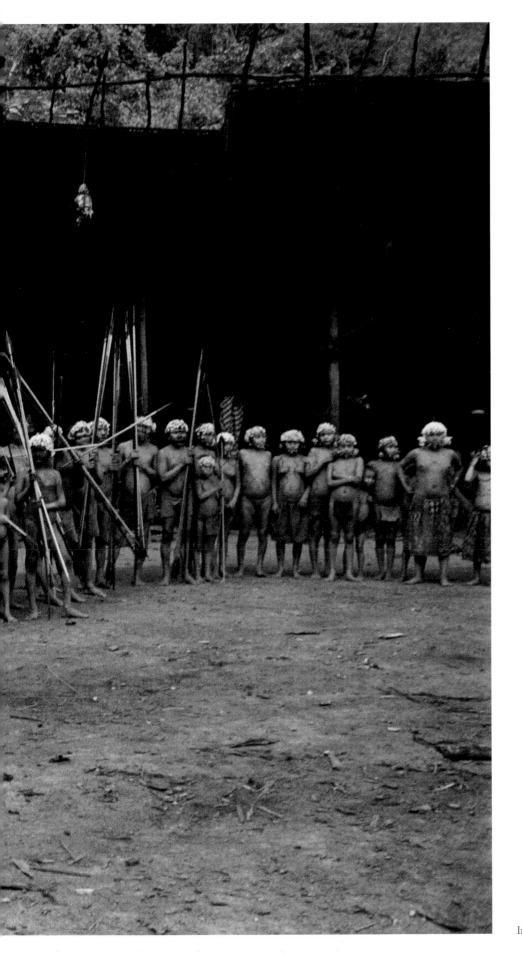

Inside a *shapono* at Mokarita-teri, Venezuela, 1997

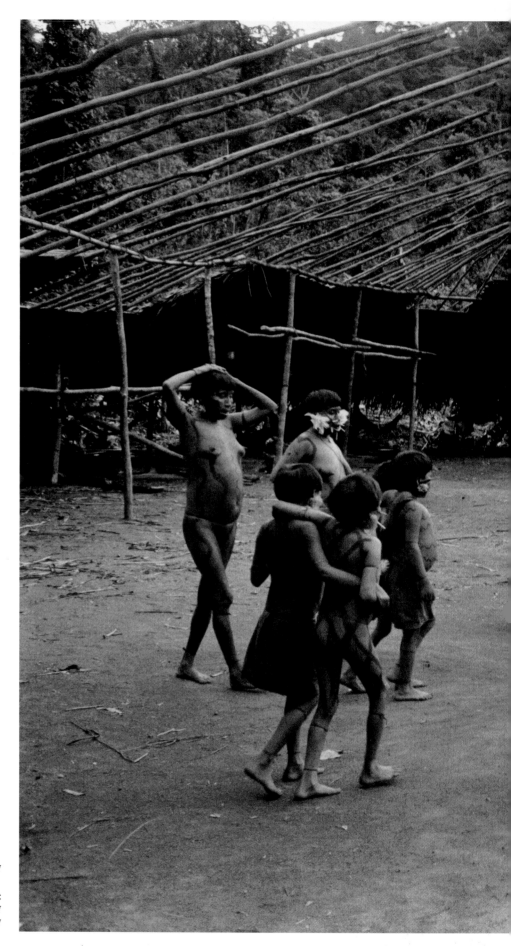

Afternoon women's dance, Venezuela, 1997

Following pages:
Woman in a traditional cotton hammock, Venezuela, 1997
Woman in full regalia, Venezuela, 1997

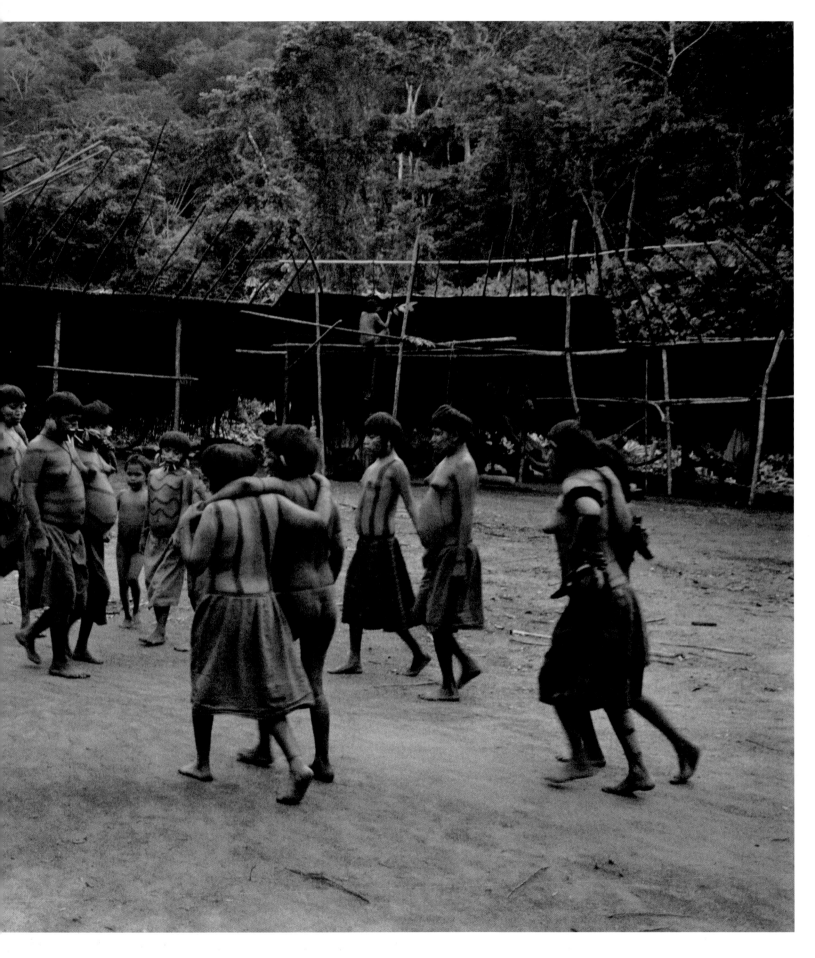

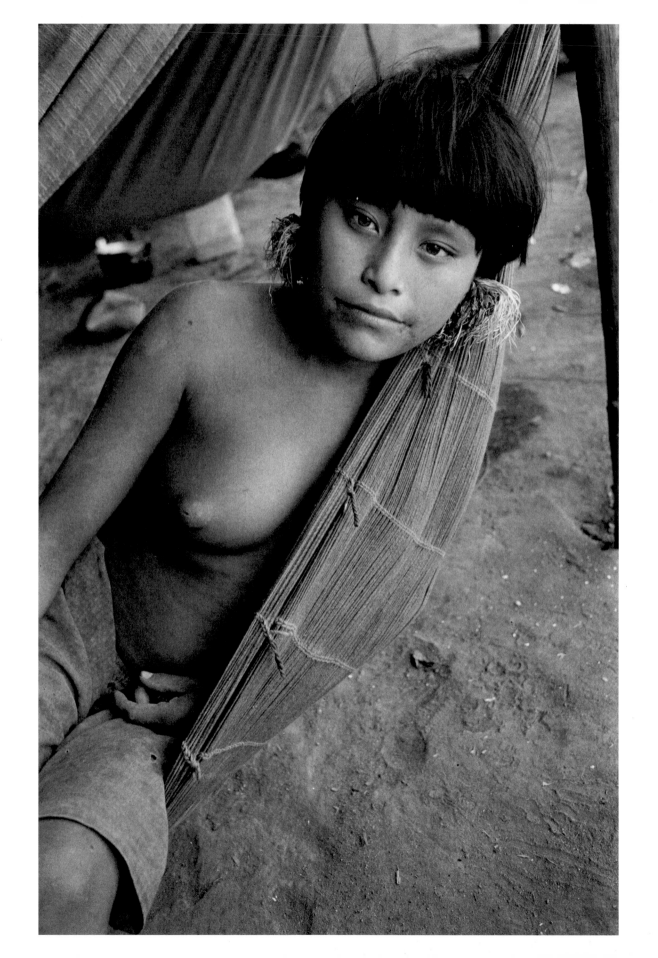

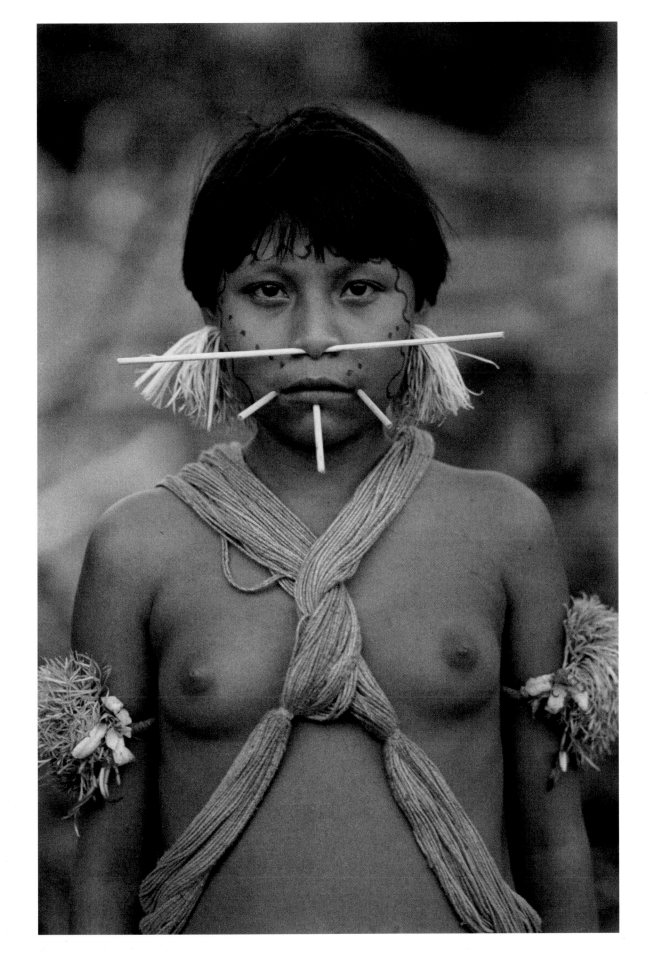

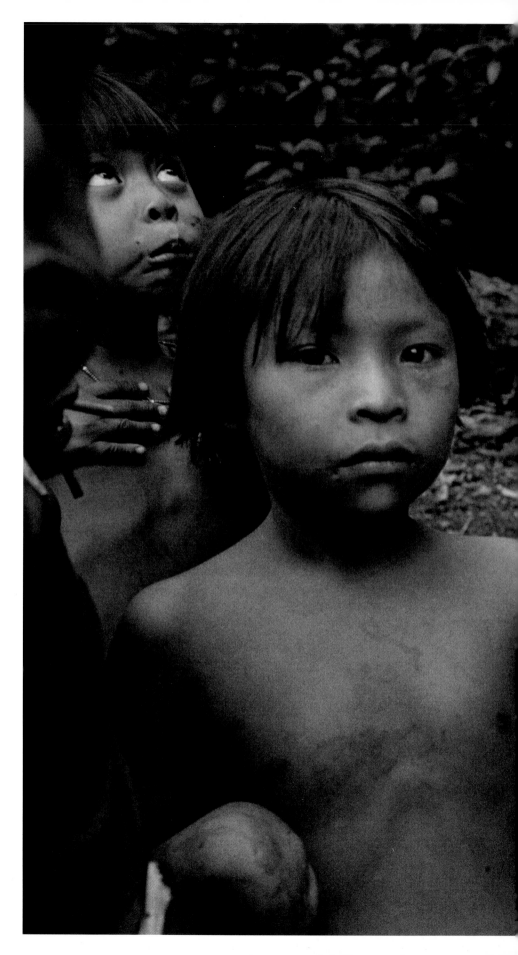

Youth at Ãrimawu-teri, Venezuela, 1997

Following pages:
Portrait of a man after inhaling *epene*, Venezuela, 1996
Yanomami mother and baby, Brazil, 1996

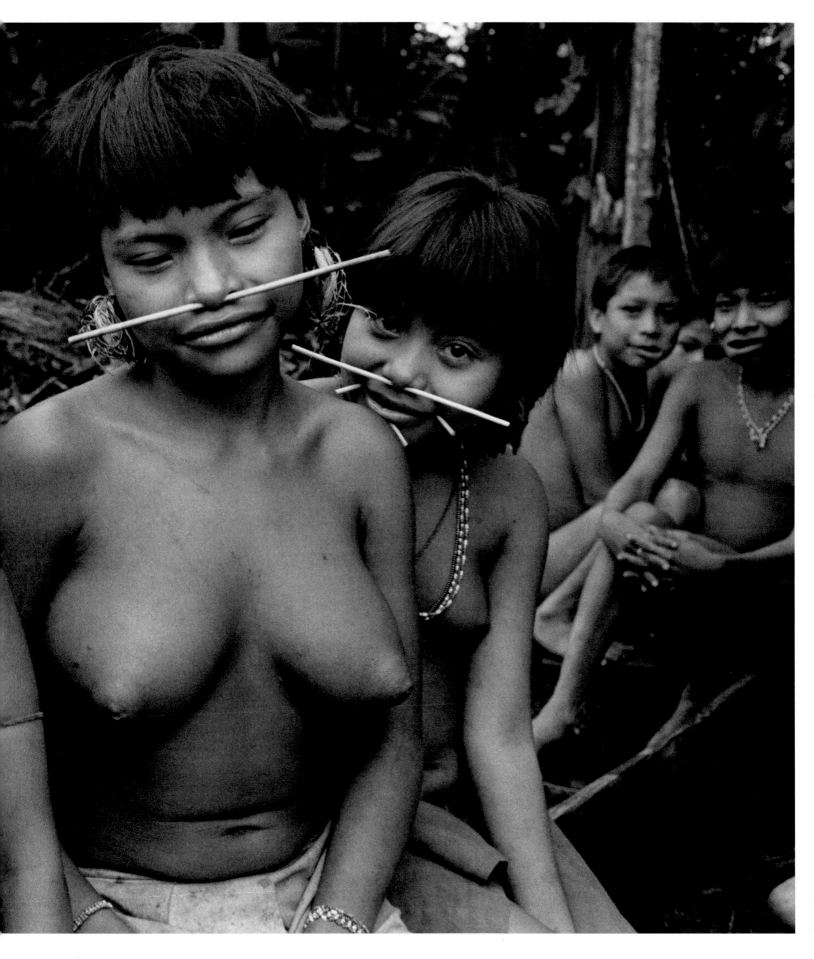

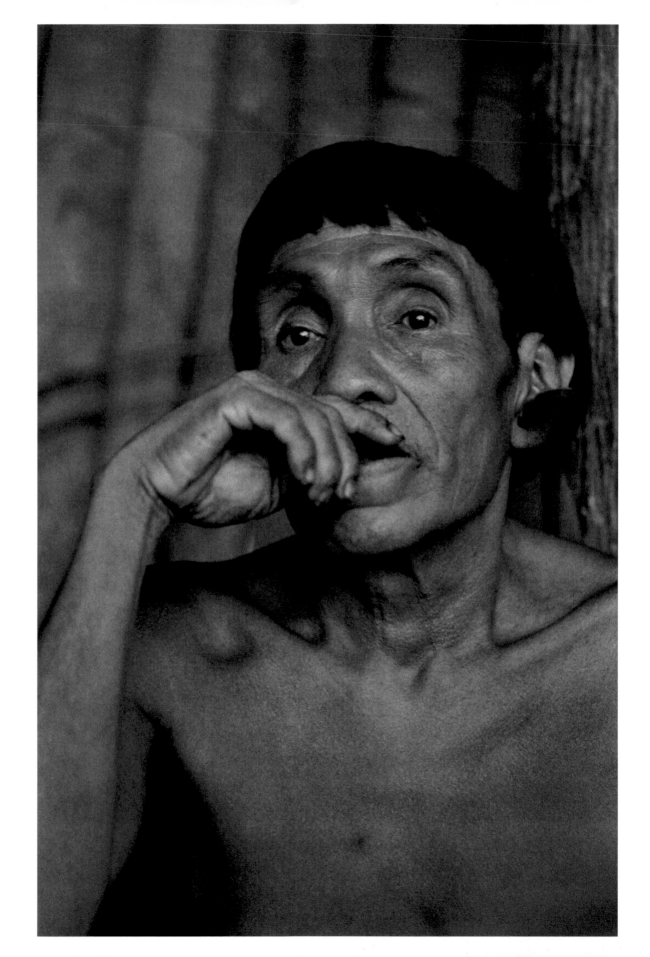

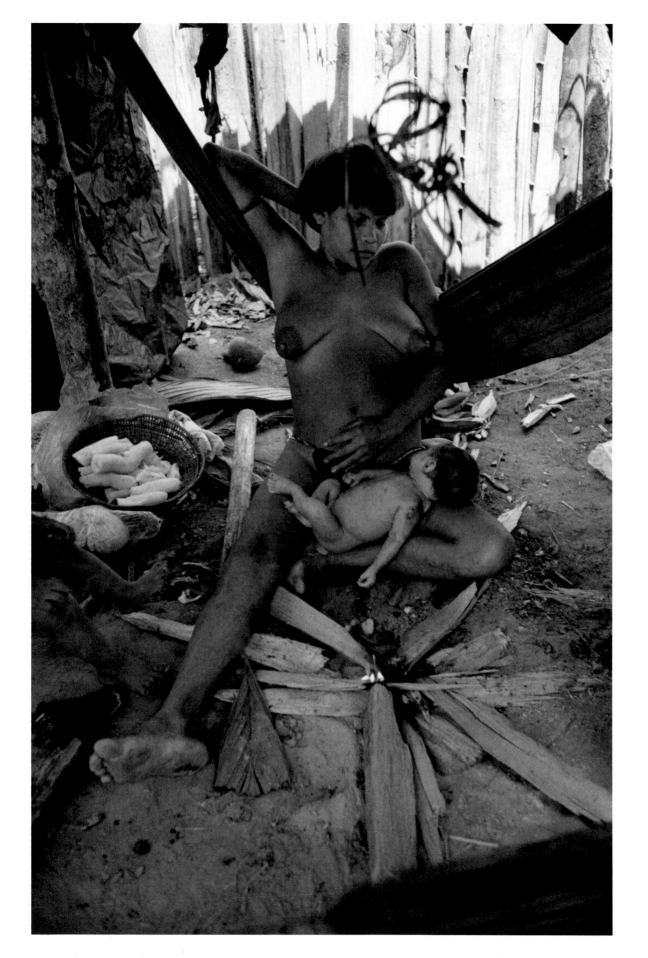

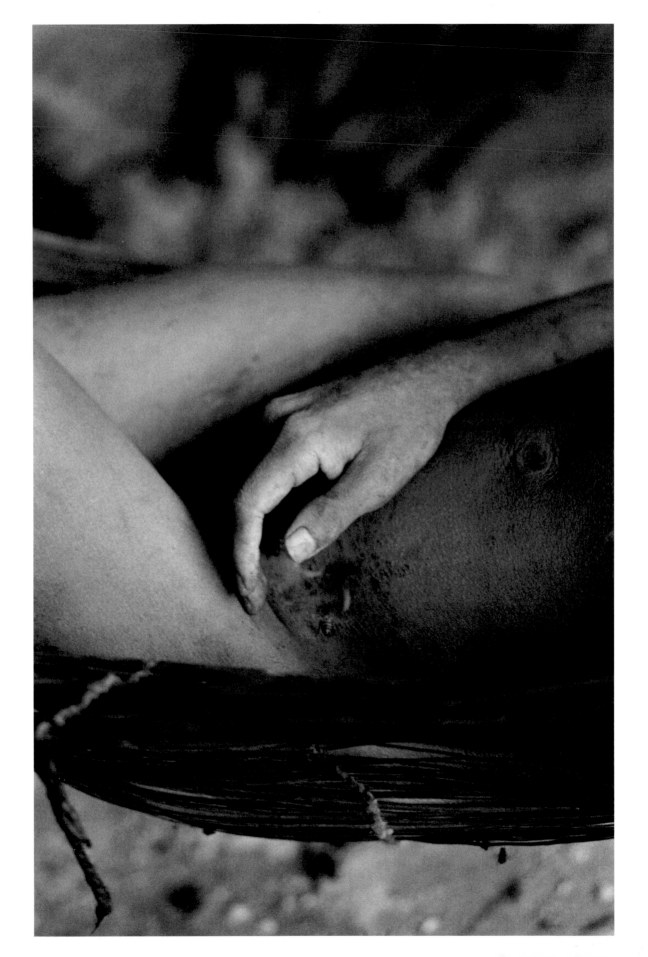

**February 14, 1997 — Venezuela**

*This morning in Irokai-teri I helped record the identity of each villager as Marinho and the nurse, Claudia Kastinger, took blood samples. There is a young woman here named Pashohapemi who was attacked by her jealous husband. He had perforated her uterus in two places with the tip of a bow, and then shot her in the back with an arrow, abandoning her for days or even weeks while he hunted, leaving her helpless. In this culture, no one will interfere or give aid because these things are considered family matters. We helped take her to the river to bathe, which gave her some comfort, and Claudinha offered medical assistance.*

Detail of Pashohapemi in the hammock, Venezuela, 1997

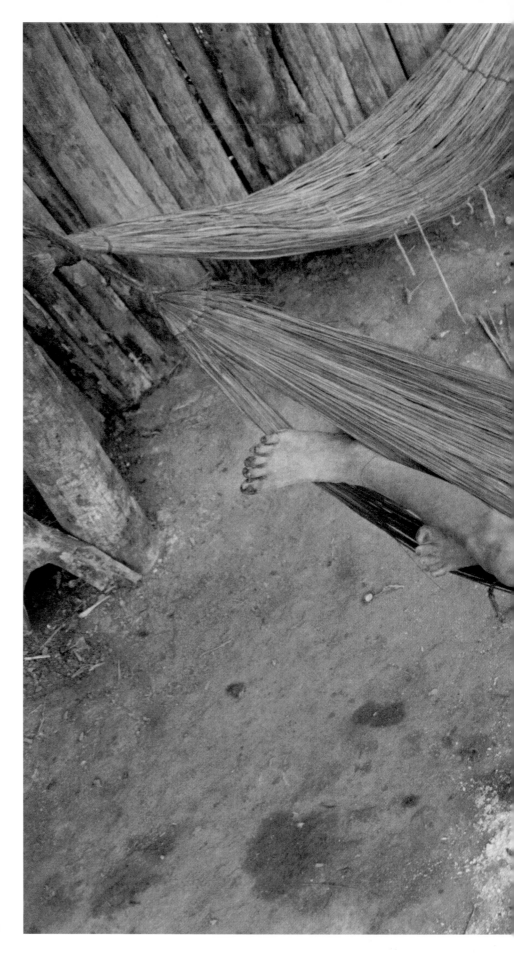

Pashohapemi, Venezuela, 1997

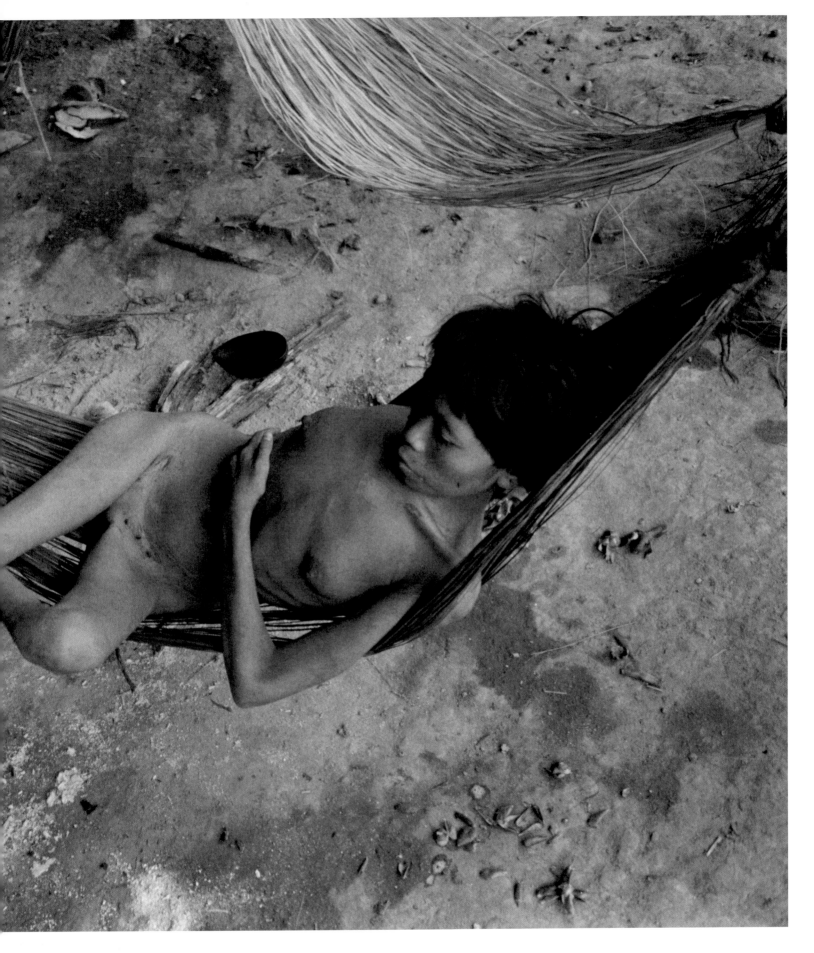

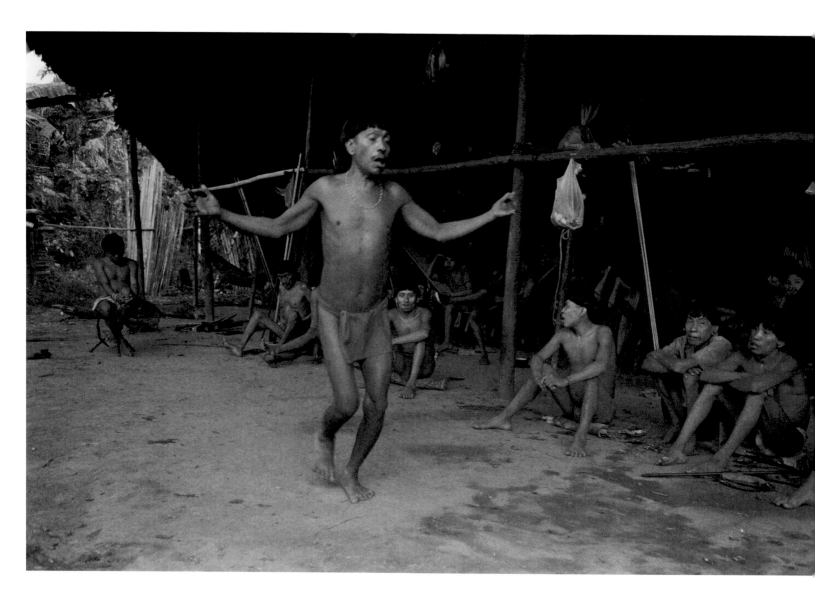

Shamanic ritual after inhaling *epene,* Venezuela, 1997

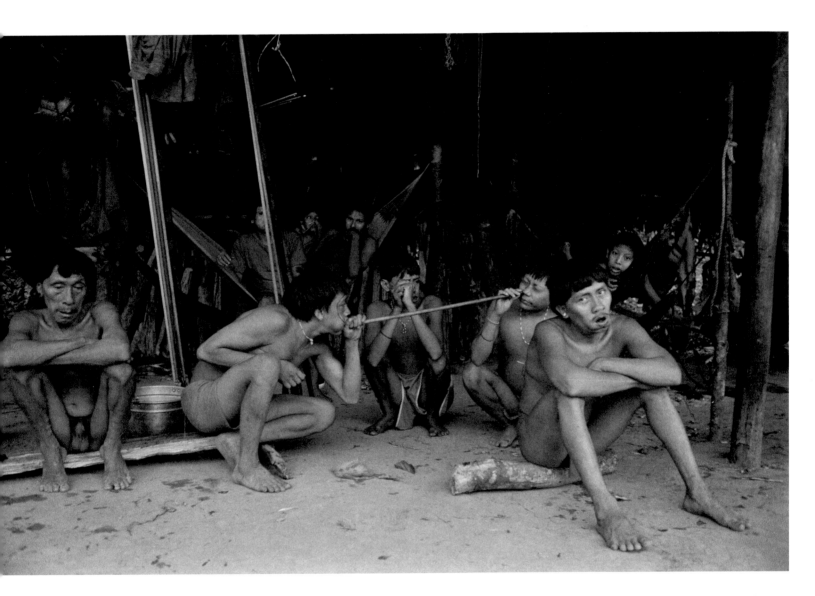

Inhaling *epene*, Venezuela, 1997

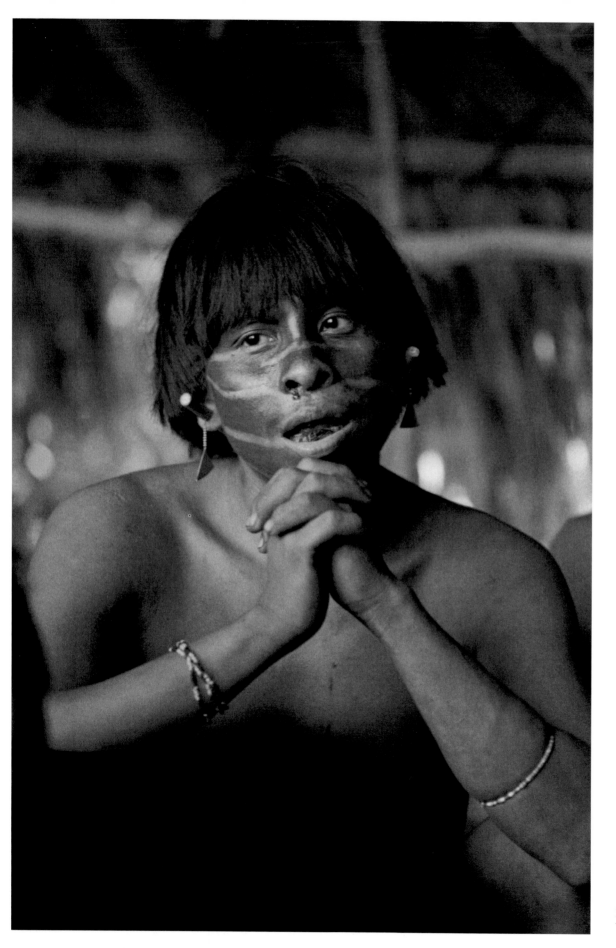

Portrait of a man after inhaling *epene* I,
Venezuela, 1996

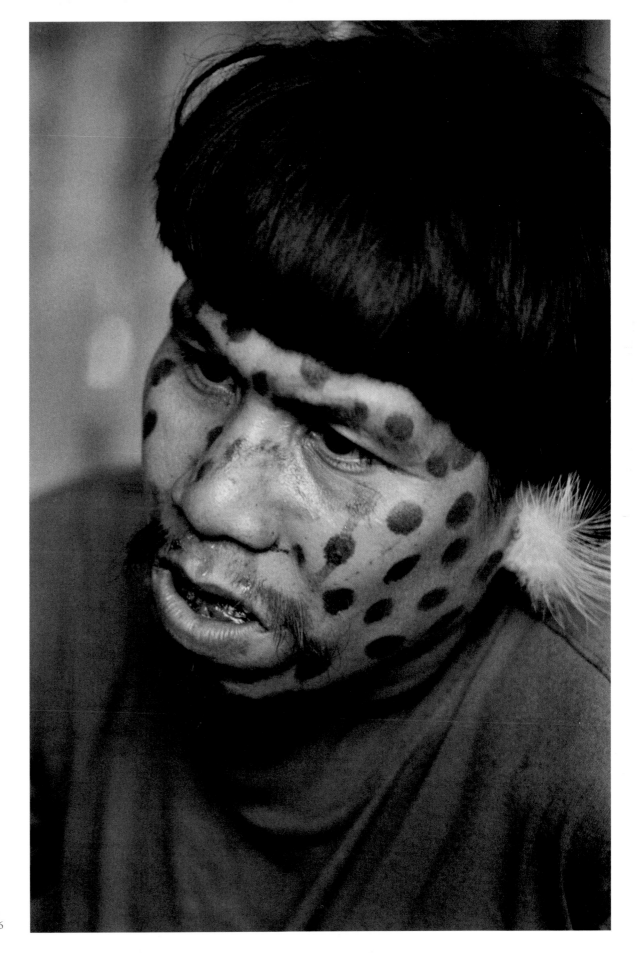

Portrait of a man after inhaling *epene* II,
Venezuela, 1996

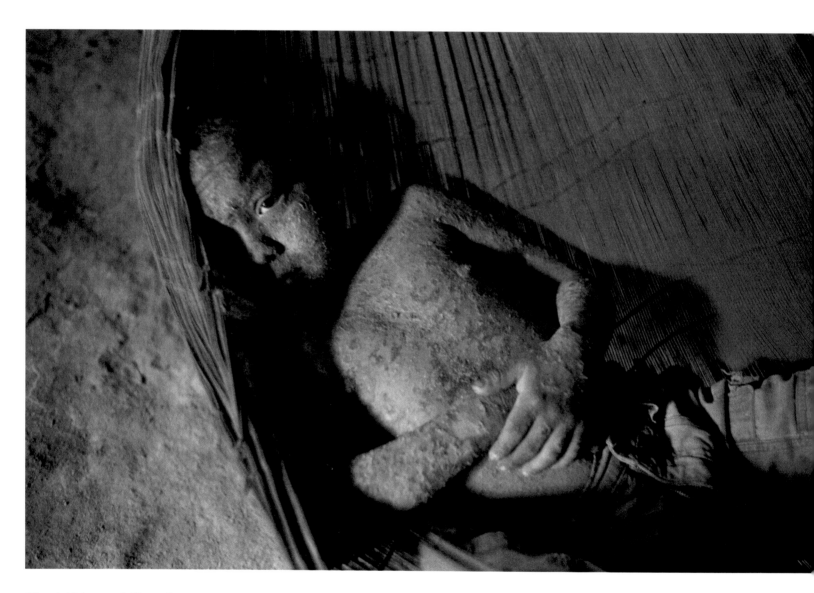

Piloto in his hammock, Venezuela, 1997

## February 22, 1997 — Venezuela

*This afternoon, I photographed Piloto, the little brother of my main guide. Piloto is afflicted with a skin disease and his health is very fragile. His skin is so delicate, it flakes off with the slightest touch. It was difficult for him to stand still, and although he was very cooperative at first, I couldn't manage more than fifteen exposures. When he took off his T-shirt, pieces of his skin came away with it. Because the mosquitoes were attracted by the odor of his body, I gave him a new T-shirt to replace the one he wore.*

*Later I helped Marinho clean slides tested for malaria and then spent the afternoon photographing the French anthropologist, Jacques Lizot, who has lived and worked in the region for more than twenty years.*

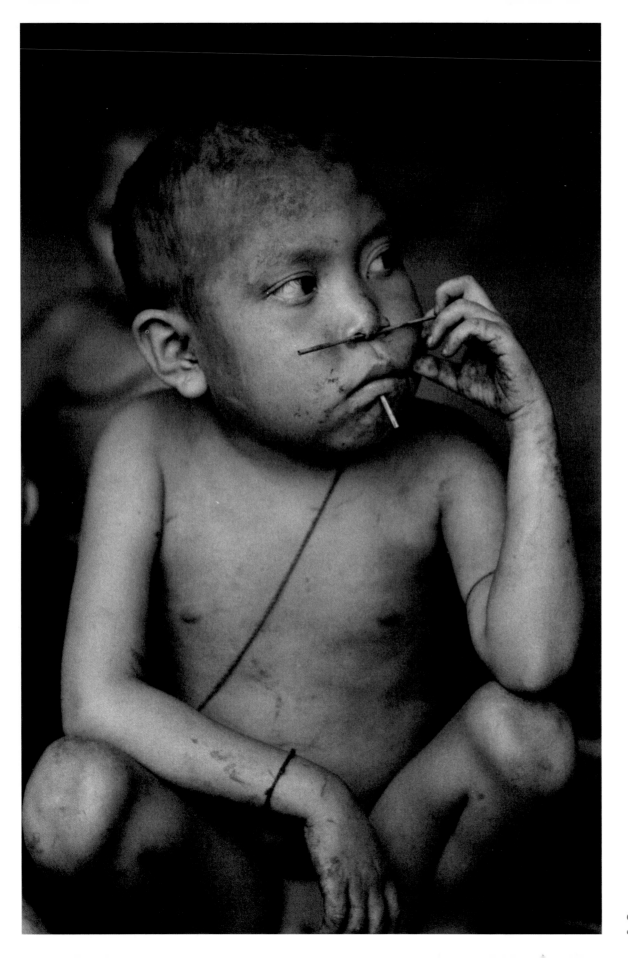

Girl from Irokai-teri with shaved head
due to illness, Venezuela, 1997

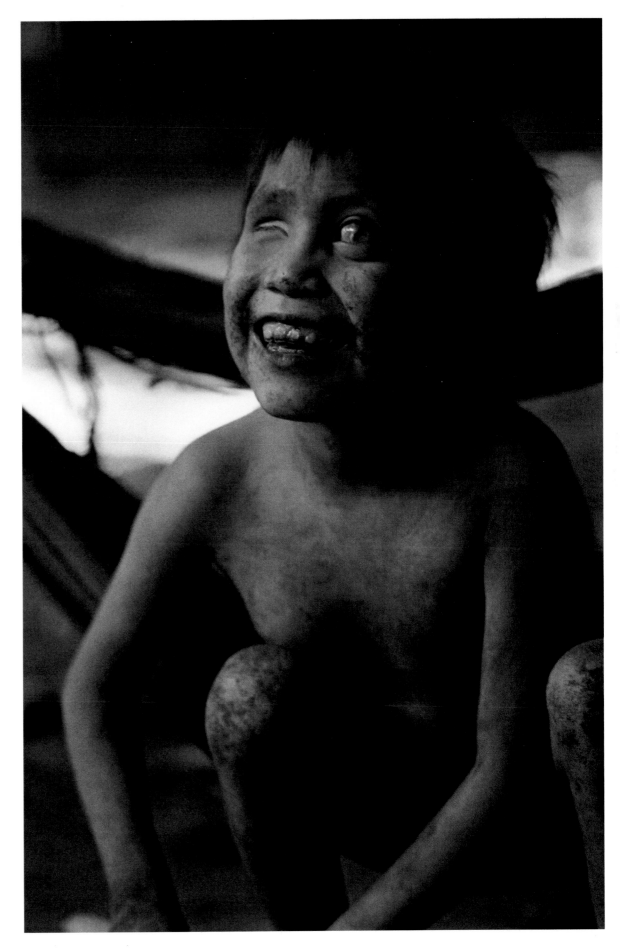

Young girl with onchocirciassis,
Venezuela, 1996

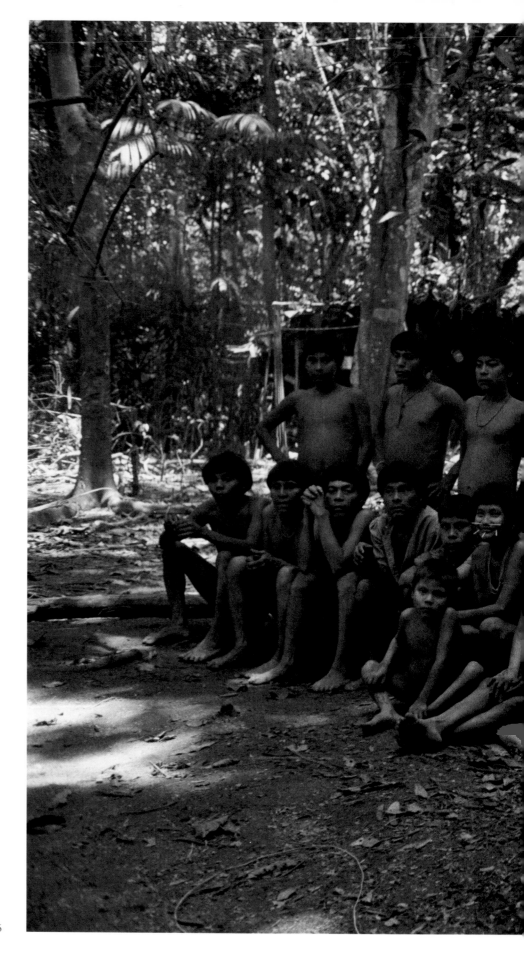

Survivors of the measles epidemic of 1968, Venezuela, 1996

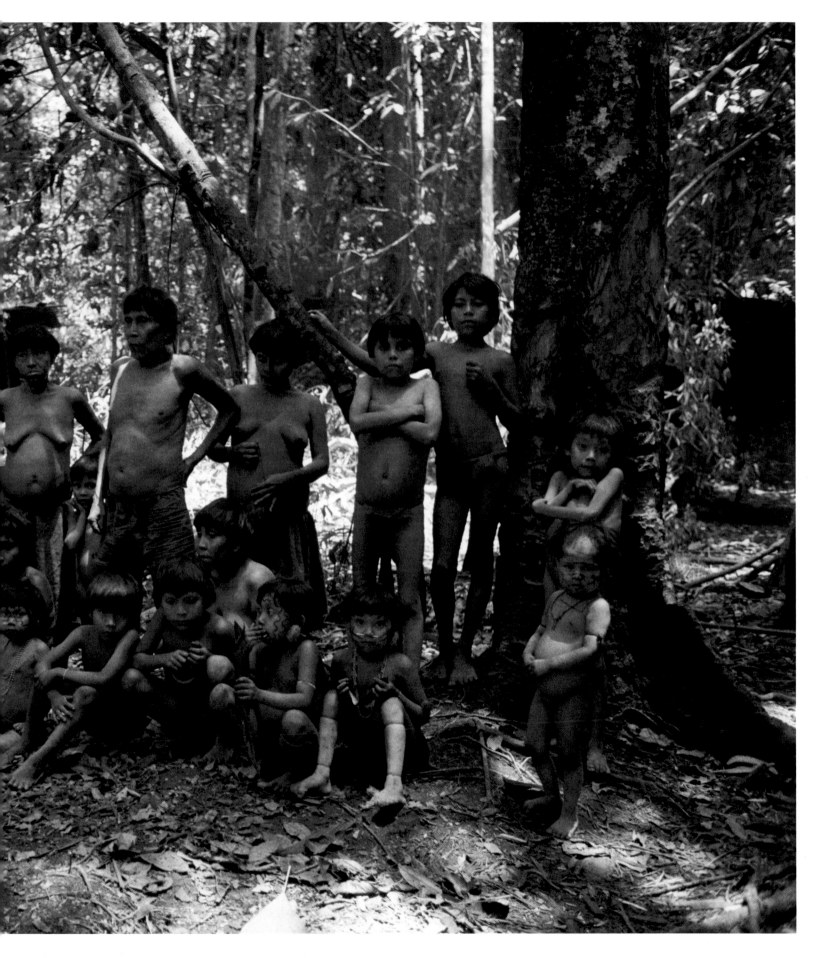

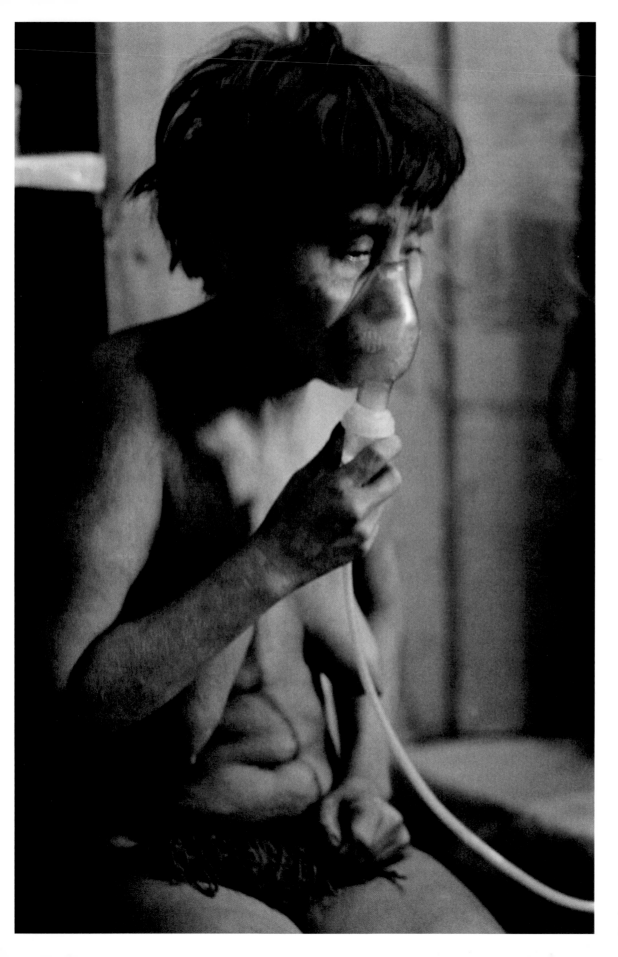

Yanomami woman undergoing
malaria treatment, Brazil, 1996

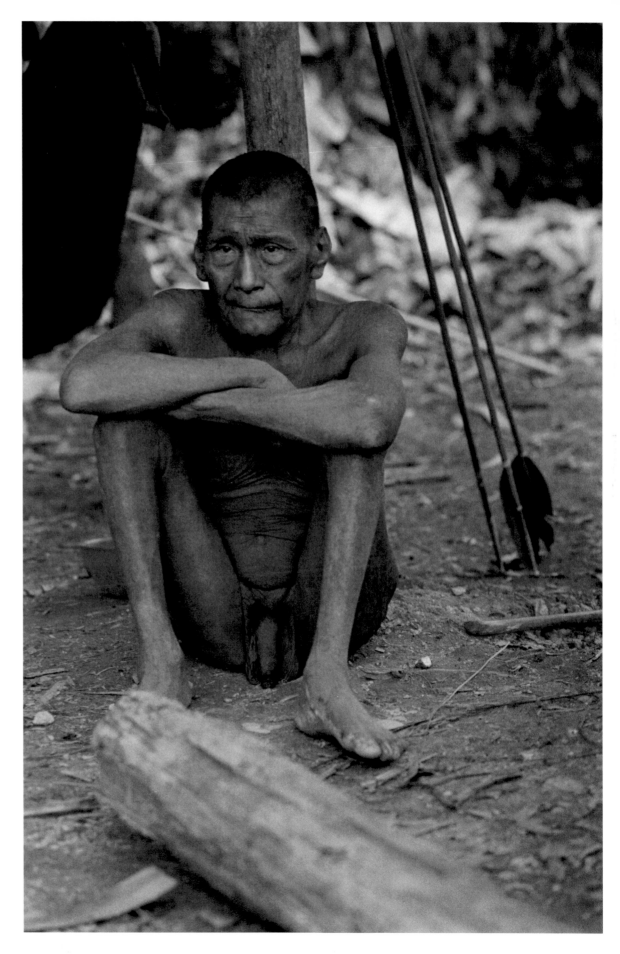

Elderly sick man, Venezuela, 1996

## January 11, 1997 — Brazil

*This afternoon, I decided to visit the Hekura Yano, which means "the house of the spirits that heal," a medical facility for the indigenous community. Its architecture is modeled after the traditional shapono, and hammocks are used in place of hospital beds. I came to investigate the health of a little Xiriana girl named Renata, who is hydrocephalic. She was born in the Upper Mucajaí River region. Although by Yanomami tradition this child would have been eliminated at birth, Renata has survived through the intervention of a Catholic nun, and has undergone experimental surgery performed by some of the local doctors.*

*She suffers, and sooner or later will die. Taking these photographs was one of the most difficult things I've ever done. It seemed to me I could sense her emotion, and I felt as though I had become part of the society that inflicted this pain upon her. My hope is that I have at least one honest image that will portray Renata's situation. Renata Xiriana was admitted to the medical facility on New Year's Day, 1997, and died the following August.*

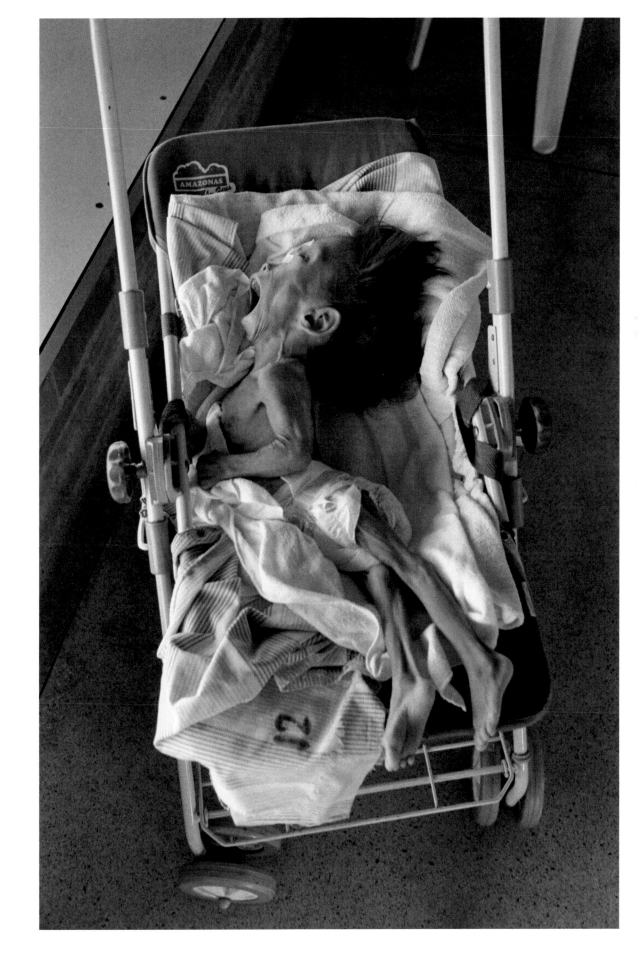

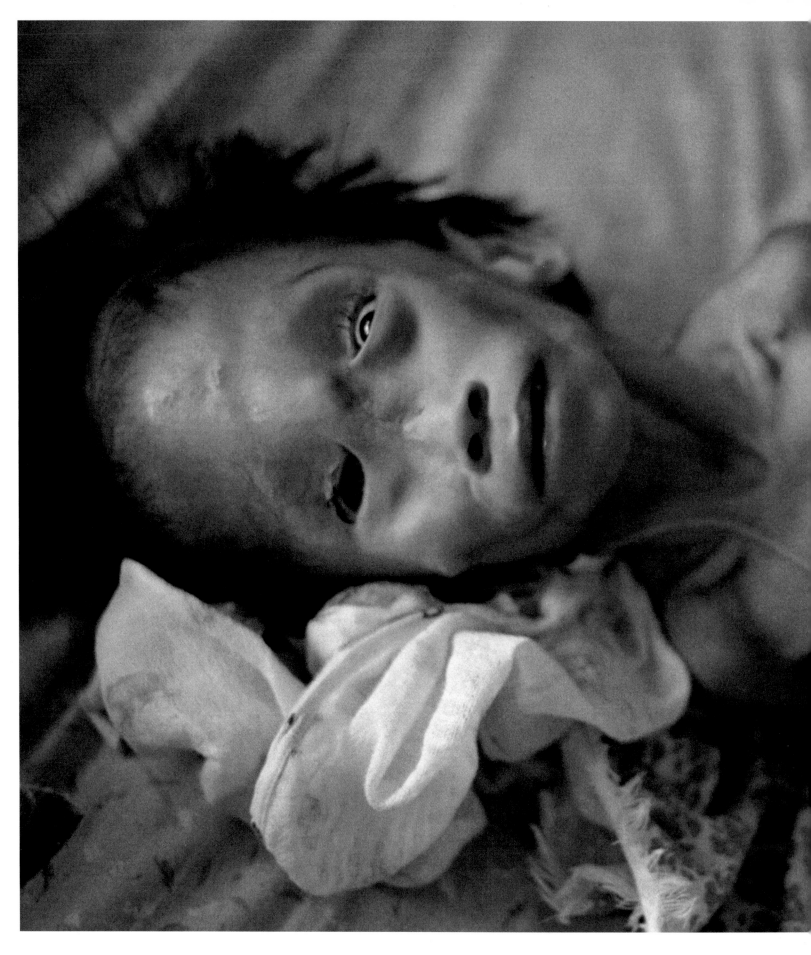

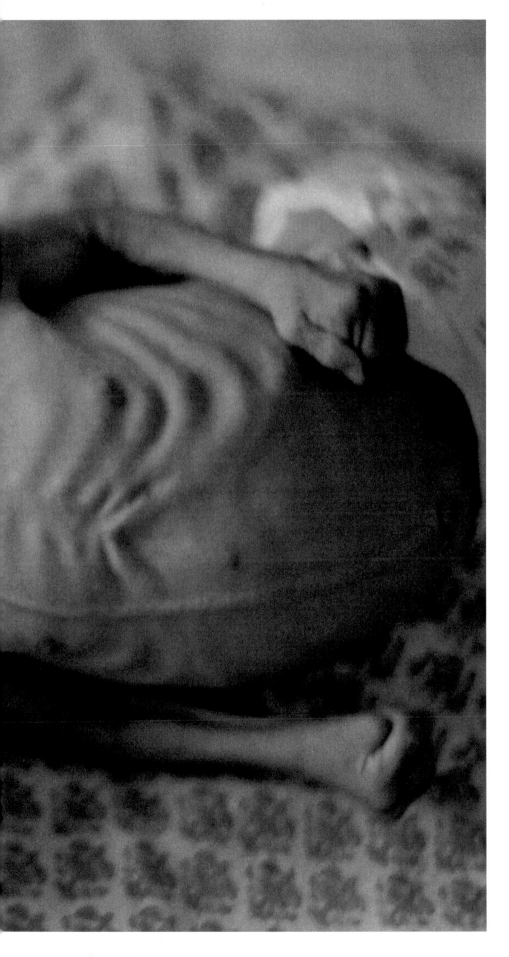

Little Renata, Brazil, 1996

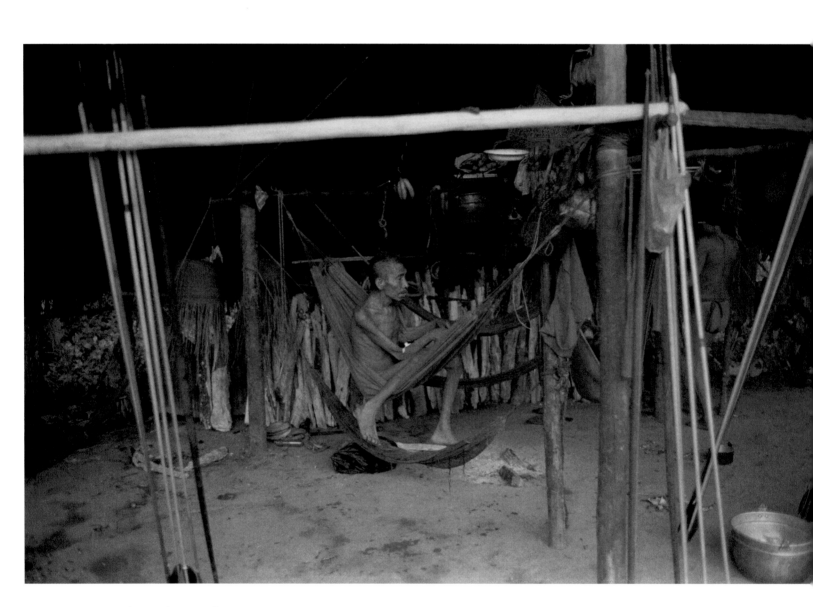

Sick elderly man in his hammock, Venezuela, 1997

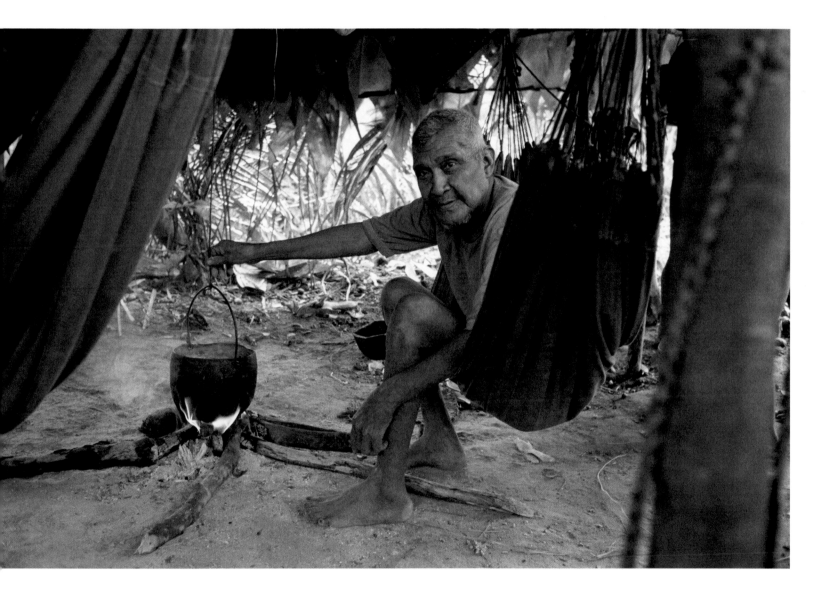

Kaobawa, Venezuela, 1996

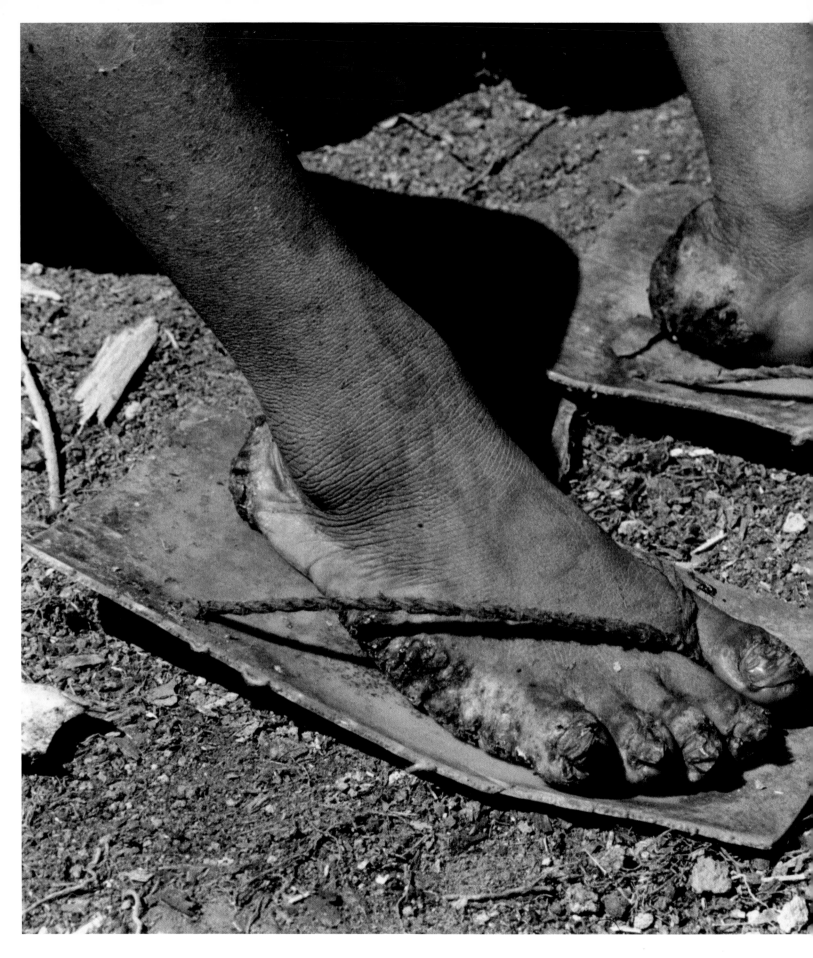

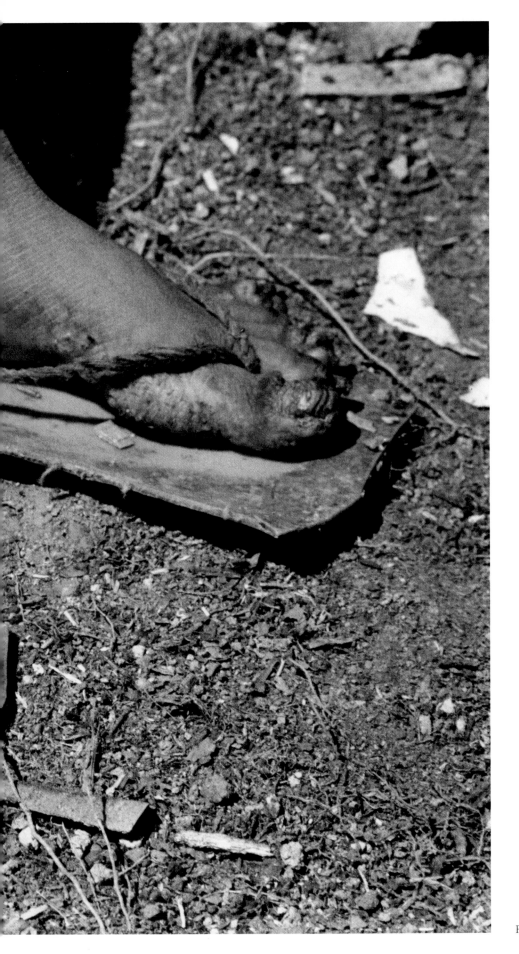

Feet infested with Amazonian jiggers, Brazil, 1996

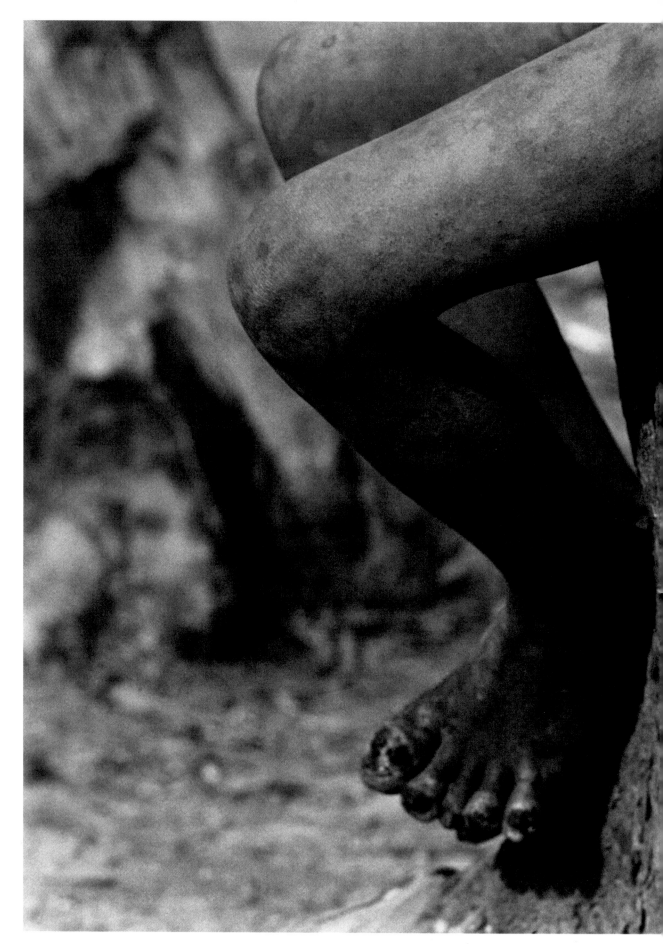

Feet and hands infested
with Amazonian jiggers,
Brazil, 1996

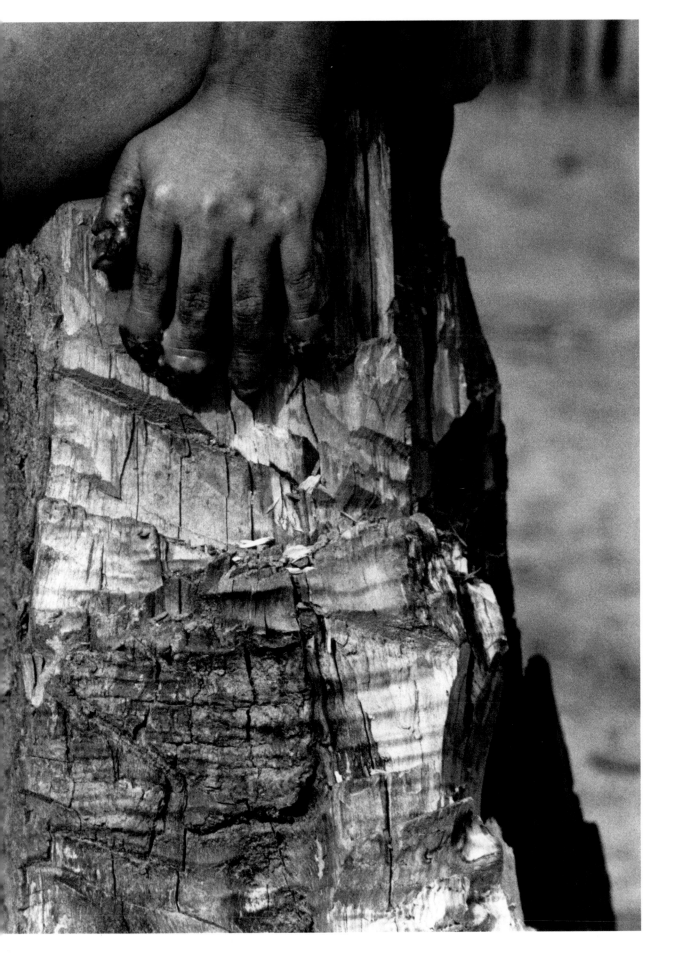

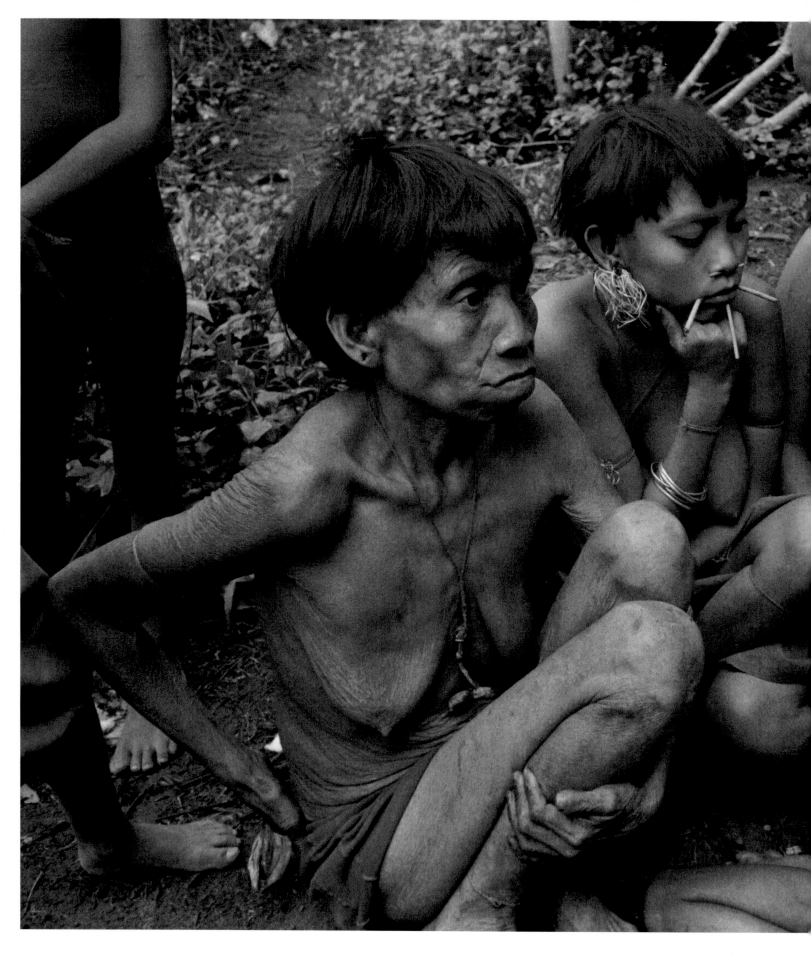

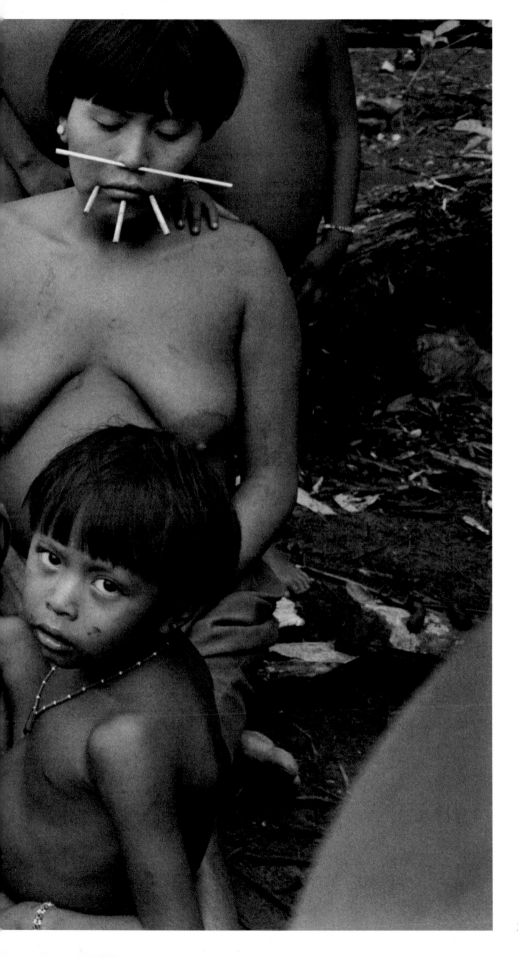

Malaria victim and relatives, Venezuela, 1997

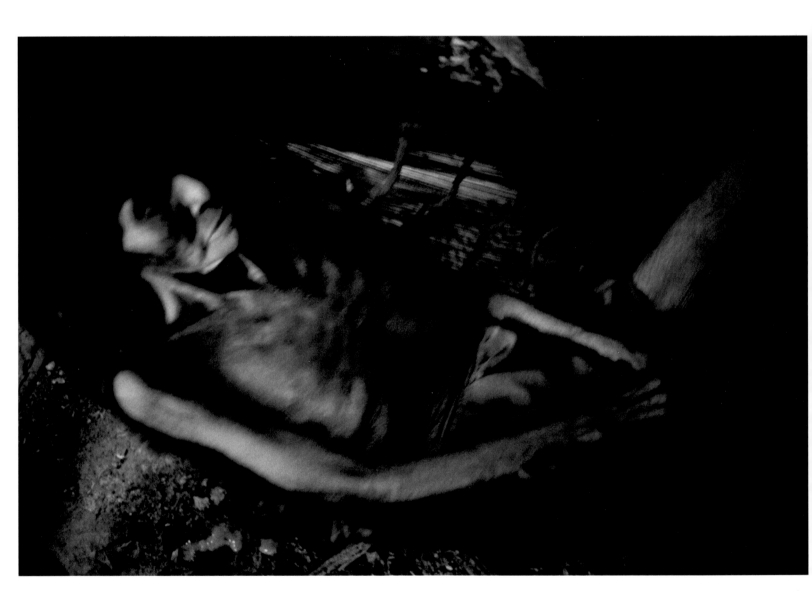

Woman with influenza and asthma, Venezuela, 1996

## August 29, 1996 — Venezuela

*As we travel, Marinho's responsibility as a microscopist is to take blood specimens, test for diseases, and offer diagnoses when possible. I am to photograph the daily life of the Yanomami as well as document illnesses among their people. In Toki, a village down the river from Kosharowa-teri, Marinho took forty-nine blood samples to test for malaria. We met an old woman who was very sick and very thin, in shocking condition. I thought she was suffering from tuberculosis, but Marinho said it was a case of influenza compounded by severe asthma, combined to create symptoms like tuberculosis.*

*Although I felt uncomfortable photographing her, I thought it was important to our mission. The first time I tried, there was too little light to make an exposure. The second time there was a storm and the light failed me again. My third opportunity came at the end of the day, with the help of our guide and community leader Pablo Mejía. The family allowed me to make three exposures.*

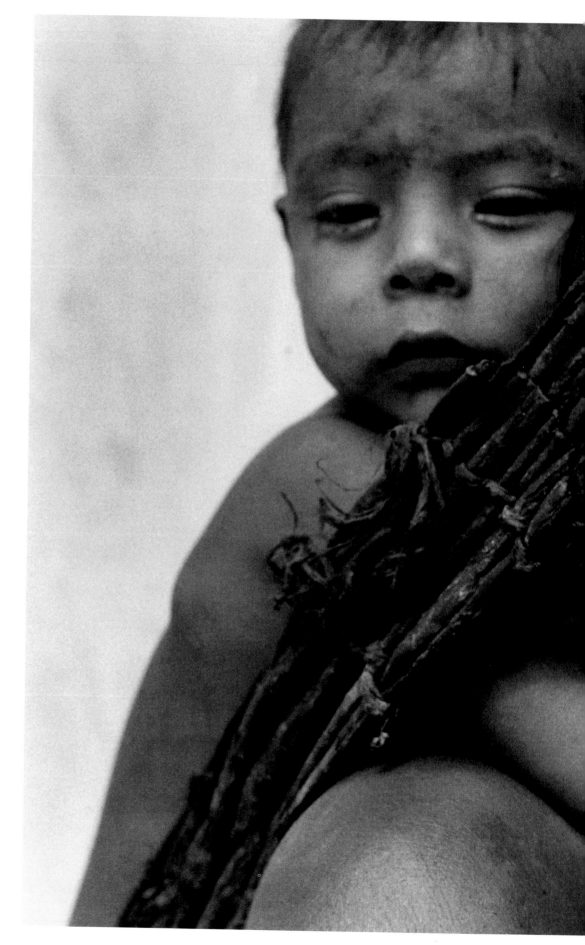

Woman with ashes and tears smeared on
her face–a Yanomami mourning custom,
Brazil, 1996

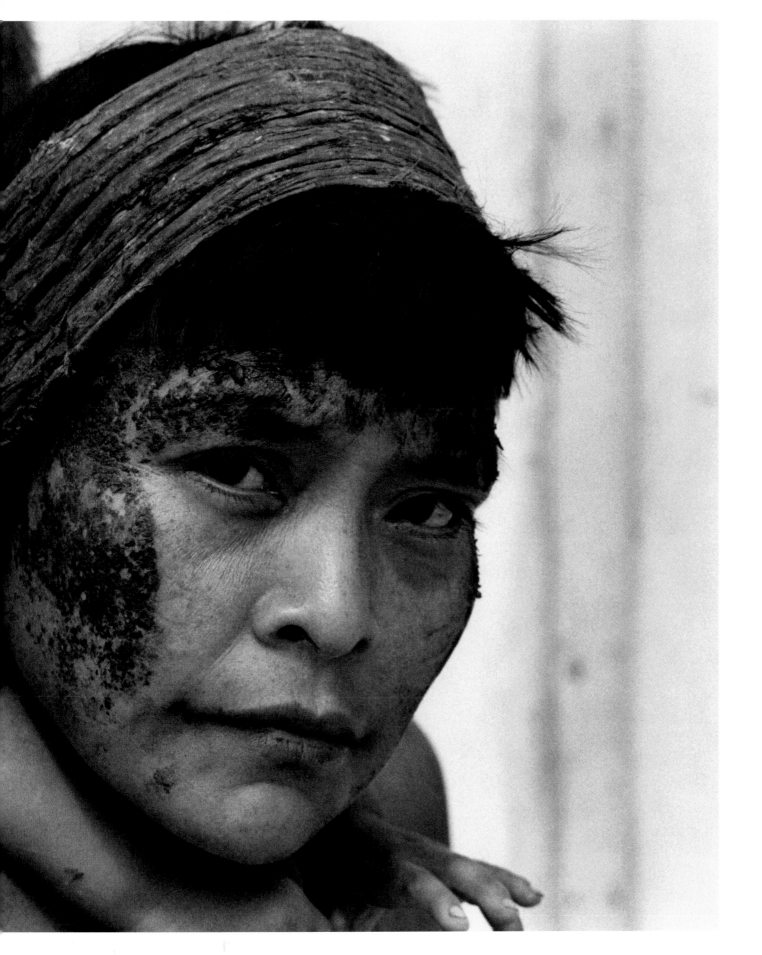

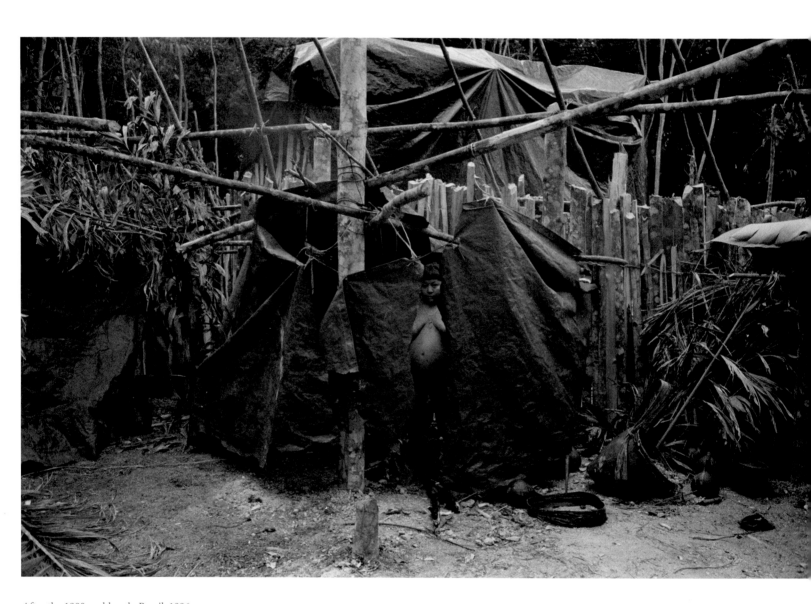

After the 1980s gold rush, Brazil, 1996

December 25, 1996 — Brazil

*Today is my first Christmas in the Amazon and my fifth day in the Yanomami area called Homoxi. Marinho continues to test for disease among the people of Therei-teri, and he and I walked to three neighboring shaponos to investigate the state of health there. The gold miners have done much damage to the culture of the Yanomami in the region, although for their part the Yanomami don't seem to care much about the loss. As a result of their trade with the miners, the Yanomami now use plastic sheeting instead of the buriti leaf to cover their shaponos, and the plastic traps the heat and humidity inside the shelters. There are rumors of fighting between communities, and when there is tribal warfare, the men can't leave the protection of the settlement and the hygiene of the community suffers. The cases here are varied. One woman has malaria. One man said the pain in his leg is caused by the sorcery of a group that is following in his steps. Another man is going completely blind. They have become beggars.*

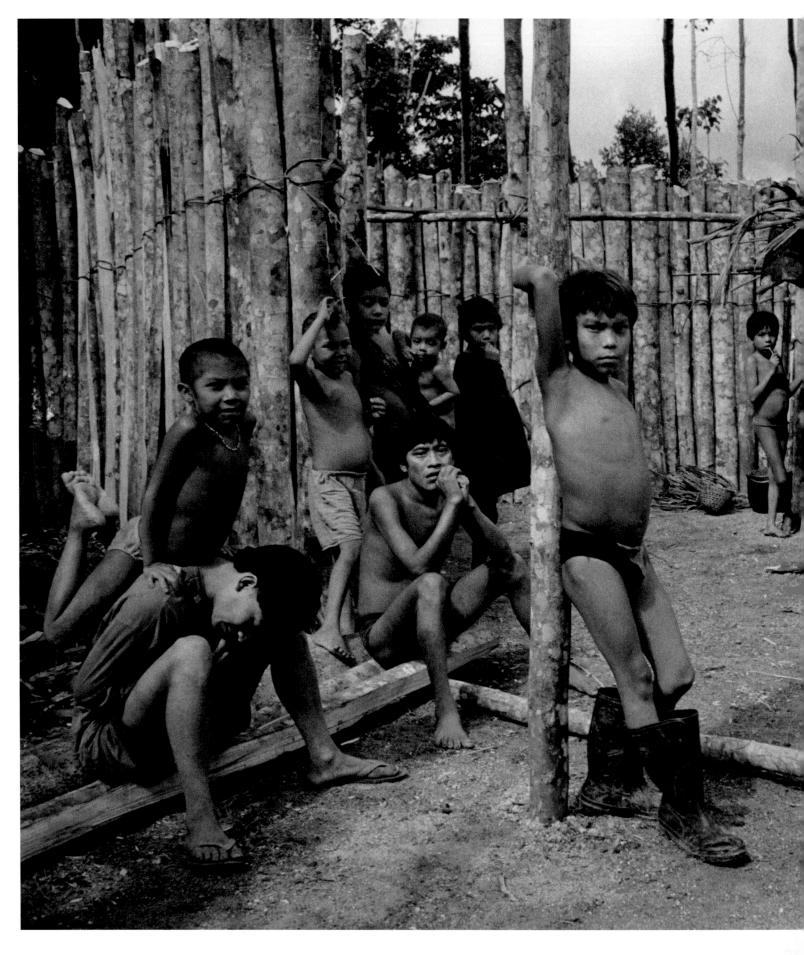

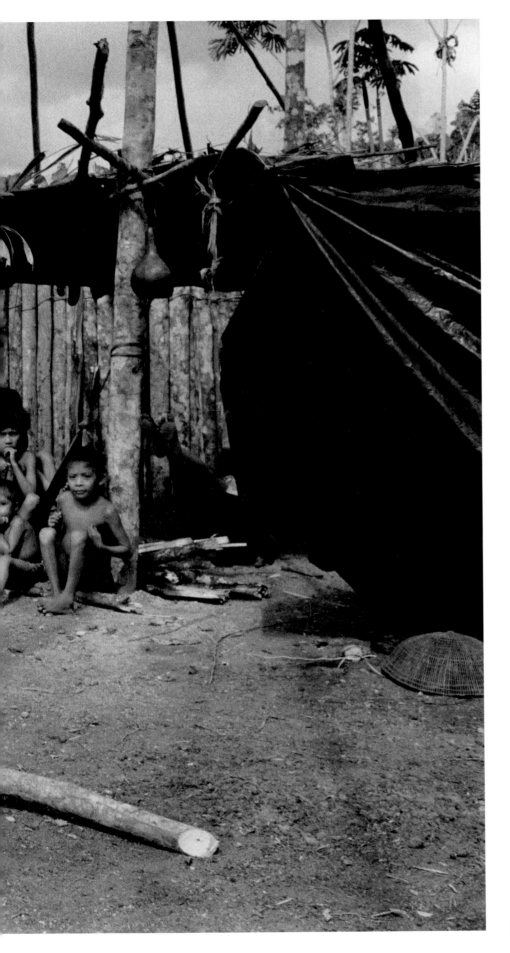

*Shapono* interior after 1980s gold rush, Brazil, 1996

### February 14, 1997 — Venezuela

*At around noon today, Claudinha and I returned from the river where we had been helping Pashohapemi bathe and care for her wounds. Marcos, our interpreter, and I joined Marinho and Claudinha on their visits to families in the village, and assisted them as Marinho collected blood samples for the malaria tests that are the focus of our mission here. Yarima's husband has given his permission for their daughter to participate in the testing, which is for her a reason for quiet celebration. A little later Yarima and some of the other women and young girls went hunting for crabs in a nearby stream. I took advantage of the soft afternoon light and made a number of exposures as they hunted, and felt certain that I would come away with a fine photograph or two as a reminder of the day.*

Crab hunting, Venezuela, 1997

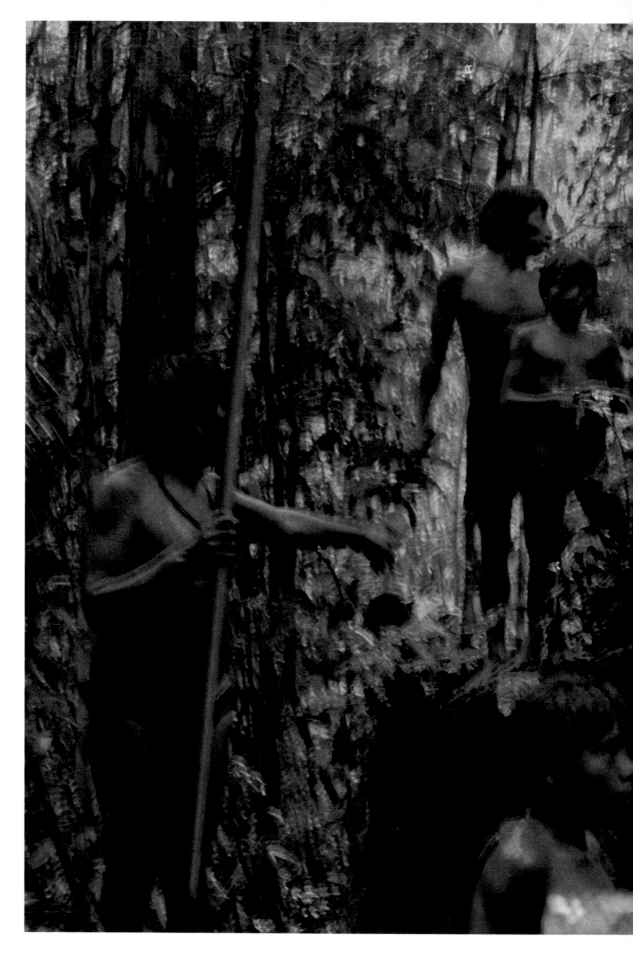

The hunt, Brazil, 1995

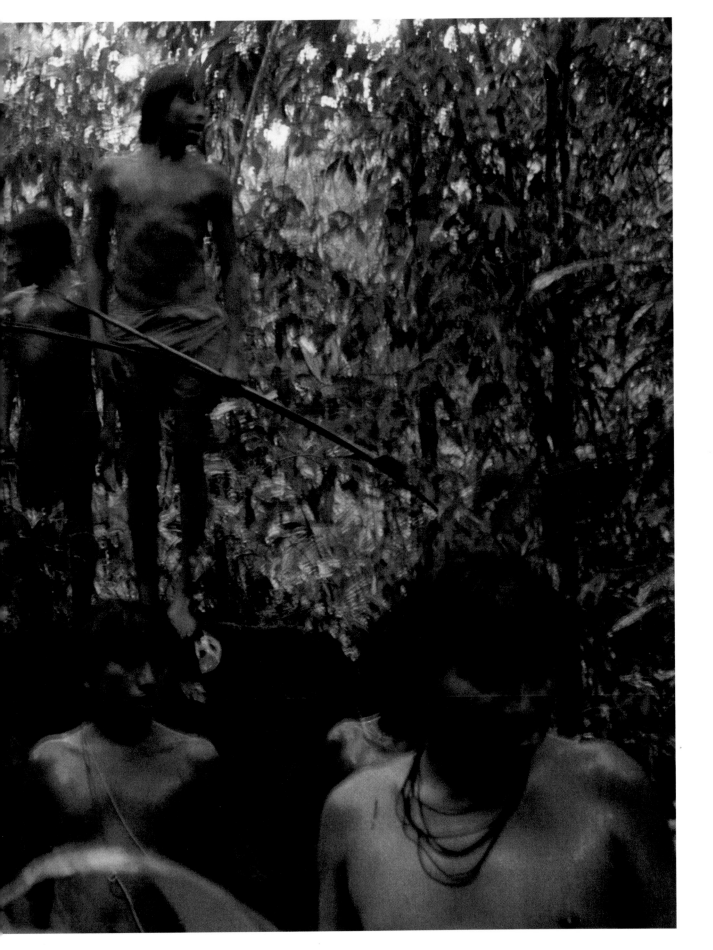

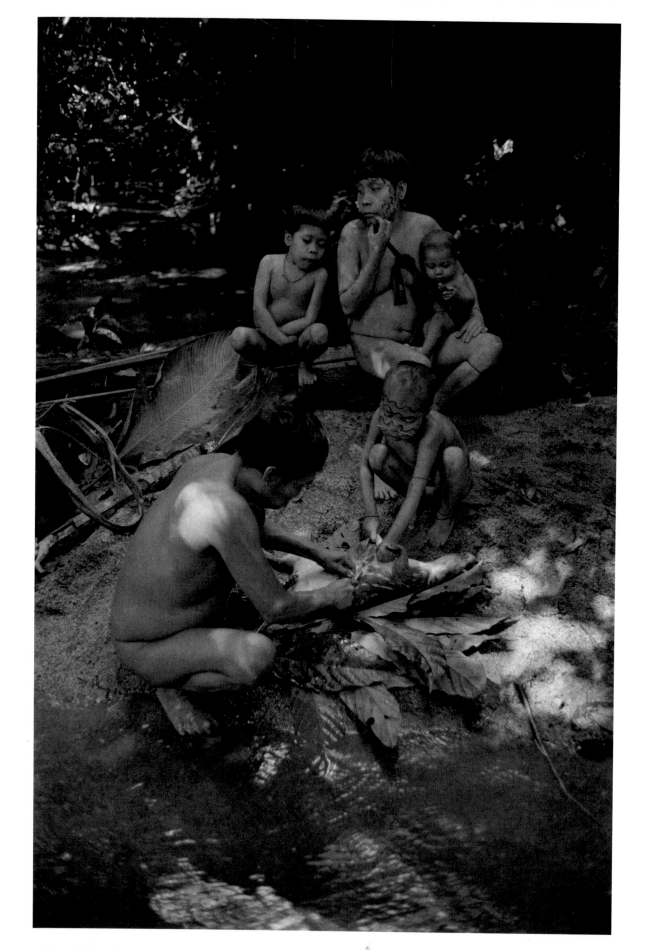

## November 21, 1995 — Brazil

*Today I met a teenager near the village who had just tried to kill an anta, a large, fat mammal of the tapir family that is rich in protein. The wounded animal had vanished in the forest, and the boy was running back to the village for men and weapons to help him track the animal and kill it. I joined them, following a trail of blood, when a big rain began. As we ran I heard a shot, but the target was a small spotted cat that was also following the blood trail. I heard two more shots and hurried to see the kill. It was my best moment to photograph the hunt—at the end, while there was less motion and more light.*

*The hunters tied the anta by its legs to a carrying pole, with its head hanging down, and four of them brought the carcass to the river and placed it on a bed of banana leaves. They dressed the meat and placed it in small baskets to take back to the village and distribute to the community (I also saw them hunt for monkeys, which they dressed and carried home in bundles for the cooking pots, providing another important source of protein for the people.) I could see that the hunter wouldn't touch the dead animal, and later learned that he wouldn't eat the meat either, out of respect to the spirits for killing the anta, although his family received their share. As the rain ended the humidity grew more and more oppressive, and in the calm that followed, I realized how dark it was in the forest, and how comfortable the Yanomami are within it. I would have been completely lost without my companions.*

Family preparing fresh game, Venezuela, 1997

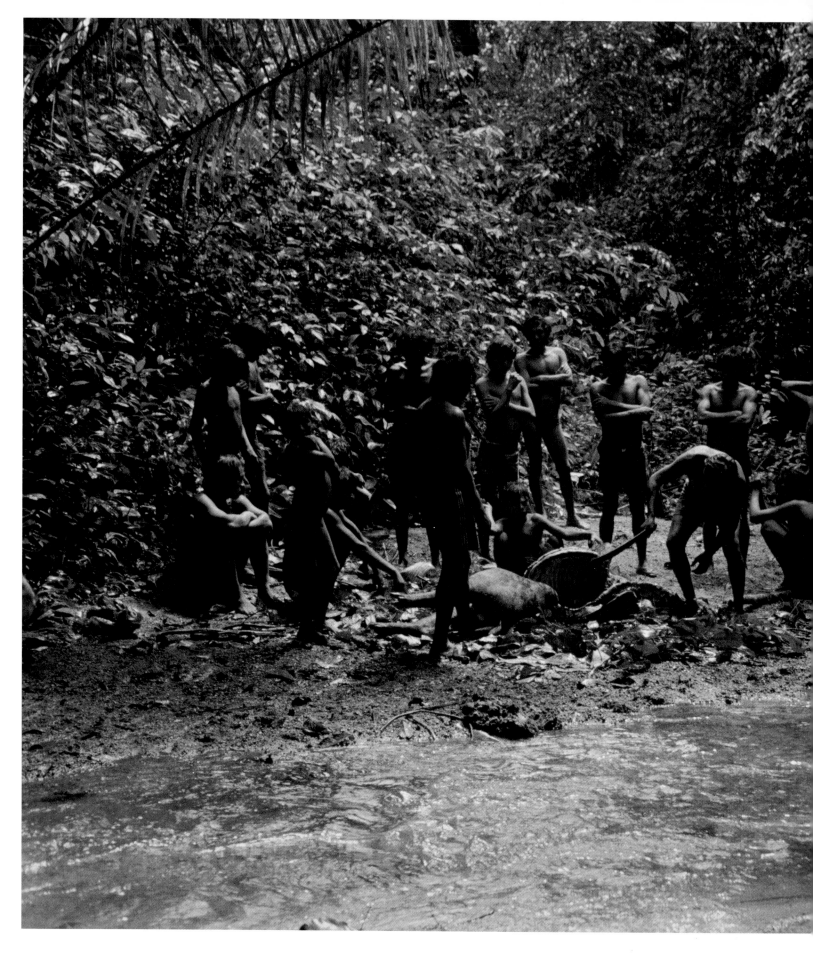

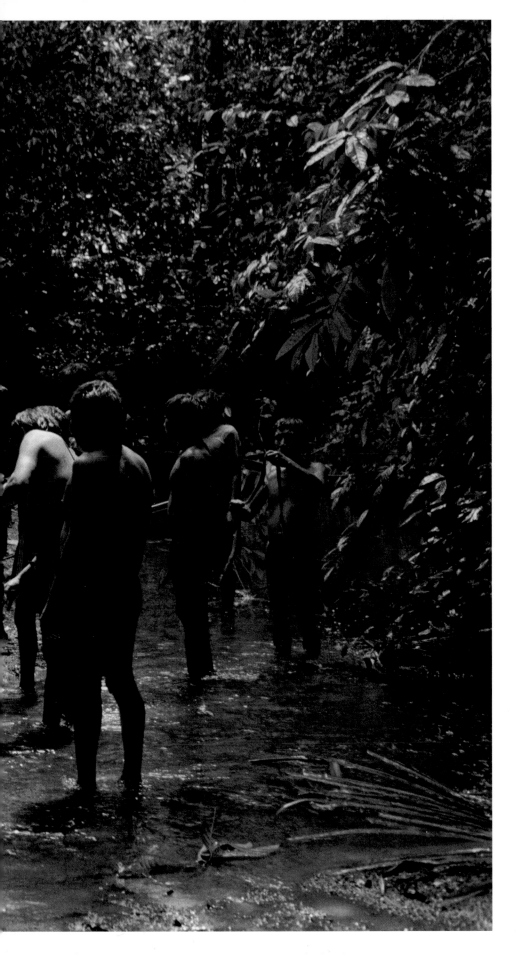

After the hunt, Brazil, 1995

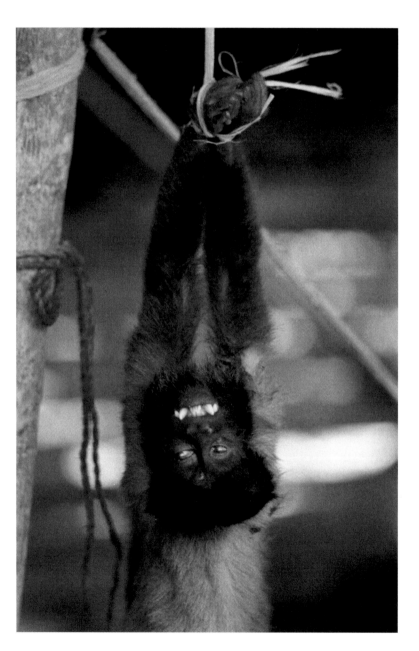

Monkey is a primary source of protein for the Yanomami people, Venezuela, 1996

### September 7, 1996 — Venezuela

*Yesterday was my very first day trekking with the Yanomami in the rainforest, and it was hard, but I did learn some things that made today much easier. How could I have known how I would respond to these new circumstances? What do you do when suddenly, right in front of you, there is a makeshift bridge, and beneath the bridge a river with who knows what kinds of creatures in it? First you think you can't cross. But if you stop, you delay the others, and so you go ahead and try to make the best of it. The porters tell me that if I take off my sneakers I can use my bare feet to grip the surface of the bridge, and that if I store my cameras in my pockets and sling them around my neck, I can keep both hands free. So today I've made life easier and much safer for everyone, and at the same time I had the chance to photograph these amazing bridges.*

The bridge, Venezuela, 1996

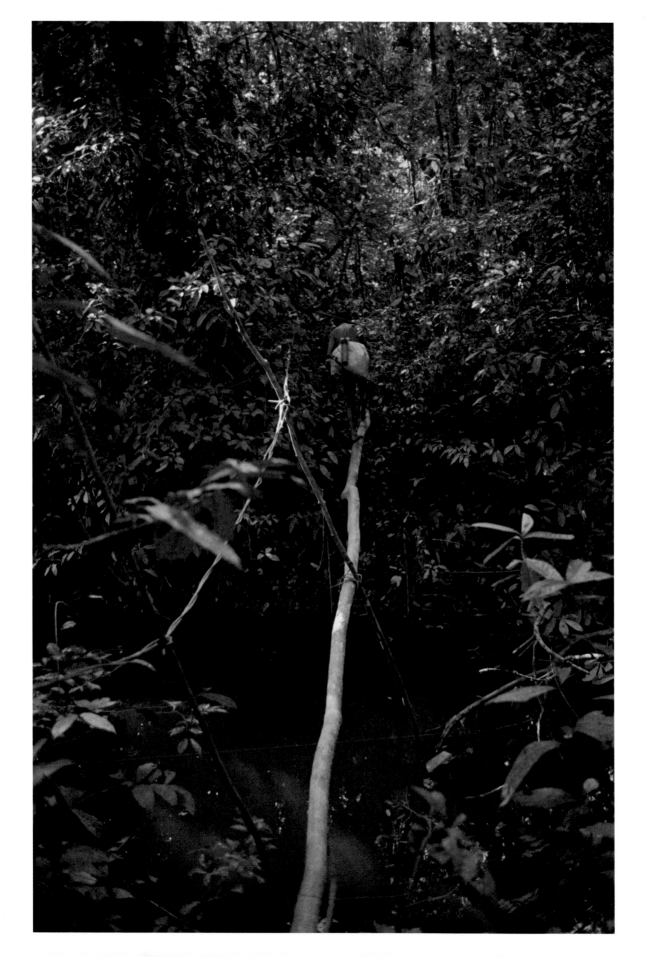

# The Yanomami

*TROPICAL FOREST DWELLERS OF VENEZUELA AND BRAZIL*

by Kenneth Good

The Yanomami of Venezuela and Brazil make up the largest population of indigenous South Americans, who for the most part still live according to cultural patterns developed over thousands of years of residence in the tropical forests of the Amazon. Some believe that the Yanomami are descendants of the second wave of Paleo-Indians who migrated over the Bering Land Bridge as long as 20,000 years ago, and who then traveled southward, arriving in the Amazon basin 15,000 years ago.

Spanning an area of approximately 200,000 square kilometers at the southern border of Venezuela and northern border of Brazil, some 26,000 tribesmen organize themselves in settlements of thirty to one hundred members. Each community occupies a single dwelling, or *shapono*, where virtually all day-to-day activities take place. The shapono is little more than a leaf-roofed frame offering necessary protection against the torrential rains that fall four to six months out of the year. This ring-shaped structure has a large open-air center where children play and adults perform shamanic rituals and inter-village ceremonies.

The Yanomami share many cultural characteristics with other tribes of the Amazon basin. They subsist by hunting game and gathering the vegetable foods of the forest. Gardens adjacent to the communal structure provide bananas and plantains that form the bulk of their diet. In this respect they differ from most other indigenous groups of the Amazon who cultivate manioc as a dietary mainstay. The Yanomami also differ from most neighboring tribes in that gardening is the exclusive domain of the men. The women gather wild foods–legumes, fruits and nuts–which provide the single reliable complement to garden crops. Because the Yanomami live in remote wooded areas away from the rivers, fish make up only a small portion of their diet. Fresh water crabs and insects such as termites and grubs provide other sources of protein and fats.

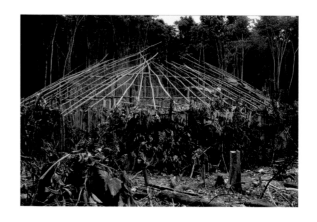

Hunting is not an easy chore in the Amazon. Alone or with a companion, the hunter ventures out in the early morning. Because most poisonous snakes are nocturnal and it is otherwise dangerous to travel after dark, and because the Yanomami believe that the malevolent spirits known as *pore* also come out at night, the hunter must return by dusk, and since the hunt is most often not successful, there are long periods with no meat at all. (A special word, *naiki*, designates a strong craving for meat.) When the hunter is fortunate enough to kill a tapir (like the anta), peccary, or other large prey, the entire village has cause for celebration, for meat is the only food distributed to everyone.

Although the community lives in an undivided dwelling, each nuclear family consisting of husband, wife, and children occupies its own section of the shapono and furnishes that area with hammocks. Made from cotton grown in the gardens of the shapono and from the vines of the forest or the inner bark of various trees, the hammocks are oriented around a familiar hearth that serves for cooking and warmth on the damp chilly nights. When the crops are exhausted the community must abandon the *shapono* and search for food elsewhere. On treks known as *wayumi*, the Yanomami take to the forest for a month or more to hunt and gather in distant areas. These sojourns increase hunting yields and the consumption of wild food, and while the villagers are gone, dung beetles and other insects clean the shapono while the crops mature and ripen for harvest.

The community social organization consists of two or more patrilineages. Young girls are betrothed at the age of four or five. At this time the prospective husband must provide meat for the parents of the intended bride. If the relationship endures, the two will begin to live as husband and wife shortly after her first menses, an event celebrated by a rite of passage, after which the girl is regarded as a woman. Within two years she will give birth to her first child.

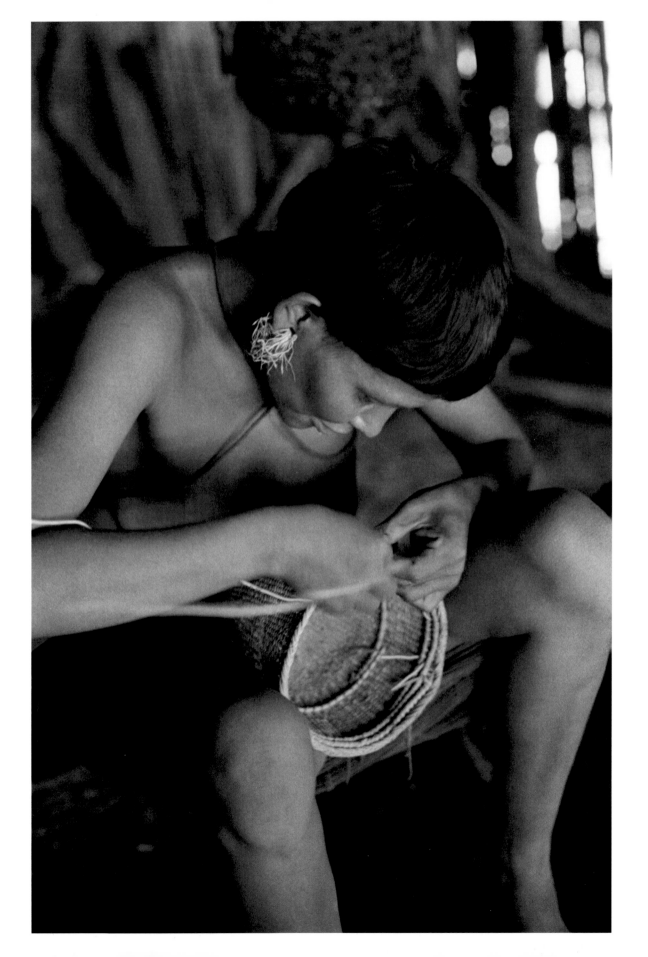

Young people are required to marry outside of their lineage, ideally to someone from the other lineage in the village. Failing this approved arrangement, a man may have to marry into another group and village and consequently separate himself from his brothers and other kin for a year or more while he performs service to the parents of his intended bride. Polygyny, or multiple-wife marriage, is accepted, but since there are more men than women in most villages, such arrangements are infrequent. Childbirth is a source of great happiness. Although children are given constant and tender care–a mother nurses her child for up to three years–mortality is so high that a child is not given a name until the age of three or four, beyond the critical years of infancy.

Social, economic, and political relationships are egalitarian. There are no marked status differences among village members, and the only true division of labor is between men and women. All men and women have a limited choice of vocation: to hunt or to gather. No one is coerced to do anything, and all share equally in the available resources. The elders are considered leaders solely by example and persuasion. By custom, one man stands out as the most outspoken and respected, and he is called the *pata* or big man–a shaman, religious leader, healer, and principal contact with the spirit world. In that capacity he attempts to heal the sick by driving out the spirits that are believed to be the cause of illness and death.

Disease takes a heavy toll on both children and adults, with malaria and respiratory infections among the most common, and the Yonomami have little resistance to diseases such as tuberculosis and hepatitis that have been introduced by outsiders. Because their communities are so remote, the afflicted have little or no access to modern medical treatment, and necessarily rely on the powers of the shaman.

In the course of healing rituals, the shaman inhales a hallucinogenic drug called *epene*, and establishes contact with the offending spirits who must be persuaded to leave the afflicted person. In the case of black magic, the shaman seeks to bring about the sickness or death of the enemy. As a result of a shaman's malevolent practices, animosity may arise between villages. If someone dies or is killed as a perceived consequence, raids intending revenge may ensue.

Among the Yonomami each community is a self-sustaining and independent village, within which each member is provided for by means of a cooperative support system.

Interpersonal relations demonstrate both camaraderie and tolerance. Nevertheless, a village cannot live in total isolation, and peaceful relations with other communities are essential for survival. In order to maintain friendly relations, the members of a village invite their neighbors to a feast occasioned by an excess of plantains in the gardens. The headman sends a messenger to invite the neighboring villagers to the feast while the men undertake a five-day hunt to provide meat for the event.

Arriving guests decorate themselves with paint made from the seeds of the onoto plant, and adorn their hair with the down of buzzards. Entering the village, they dance around the inner circle, and their hosts invite them to the comfort of a hammock, where they are served a plantain drink. After a day or two the visitors return home bearing baskets of boiled plantains and smoked meats.

Without doubt their greatest preoccupation is physical survival in a relatively harsh environment. Food is not always plentiful, and periodic epidemics have devastating effects on the community. Although the Yanomami today live in remote areas with little outside contact, the world is closing in on them. Many changes will take place, both voluntarily, as the Yanomami are attracted to Western goods and technology, and involuntarily, as commercial interests penetrate the forest.

Contact with the Yanomami began at the beginning of the twentieth century as rubber tappers, hunters, and lumberjacks penetrated their lands. Some researchers believe contact occurred much earlier through the activities of slave raiders as they encroached upon areas of indigenous settlement. Perhaps as a consequence, the Yanomami may have abandoned the resources of the rivers and fled deep into the forests.

What is certain is that in recent years gold miners have illegally entered Yanomami territories bringing sickness and death. In the state of Roraima (Brazil) between 1987 and 1990, as many as 40,000 miners–about four times the total Yanomami population in Brazil–have ravished the Yanomami homeland. These miners have polluted their streams and destroyed ancestral hunting lands. It remains to be seen if the governments and organizations involved in contact issues today will care enough to assure the integrity and survival of the health and culture of these threatened people.

Nose piercing, Brazil, 1995

Following pages:
Yarima and son, Venezuela, 1996
Girl from Shashanawa-teri, Venezuela, 1996

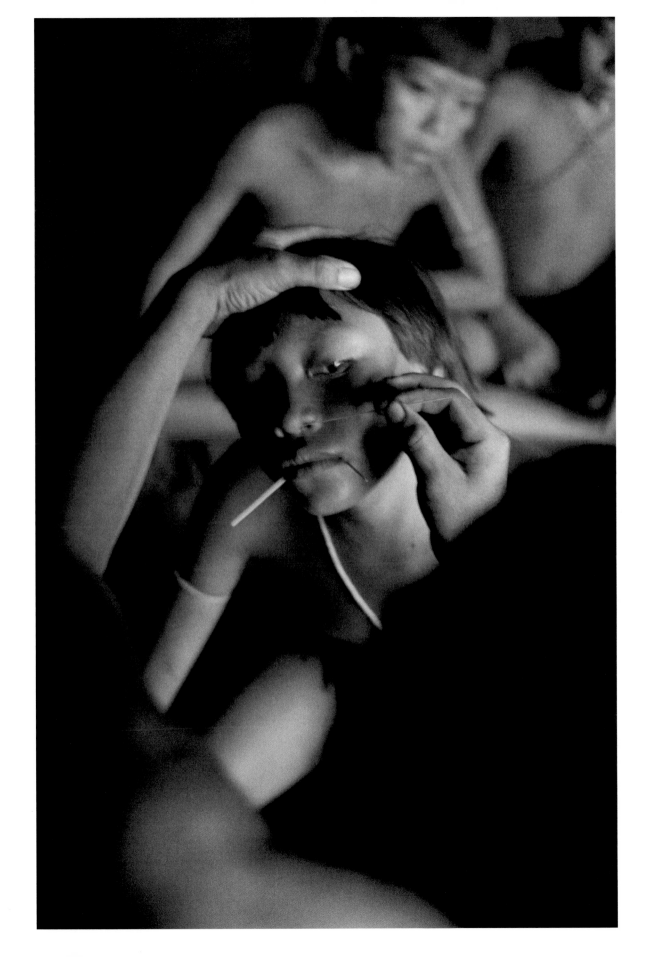

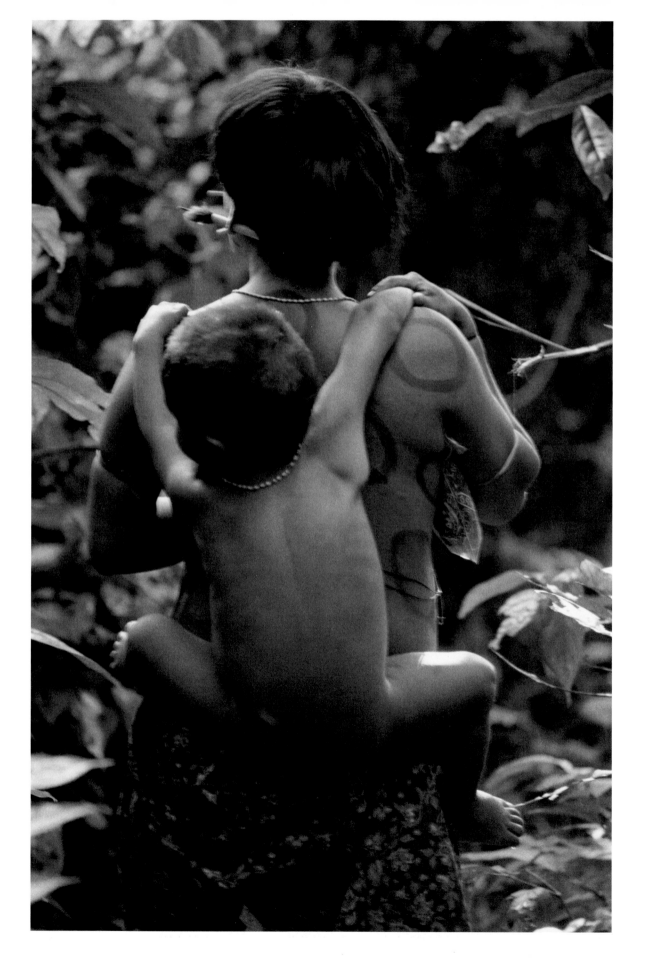

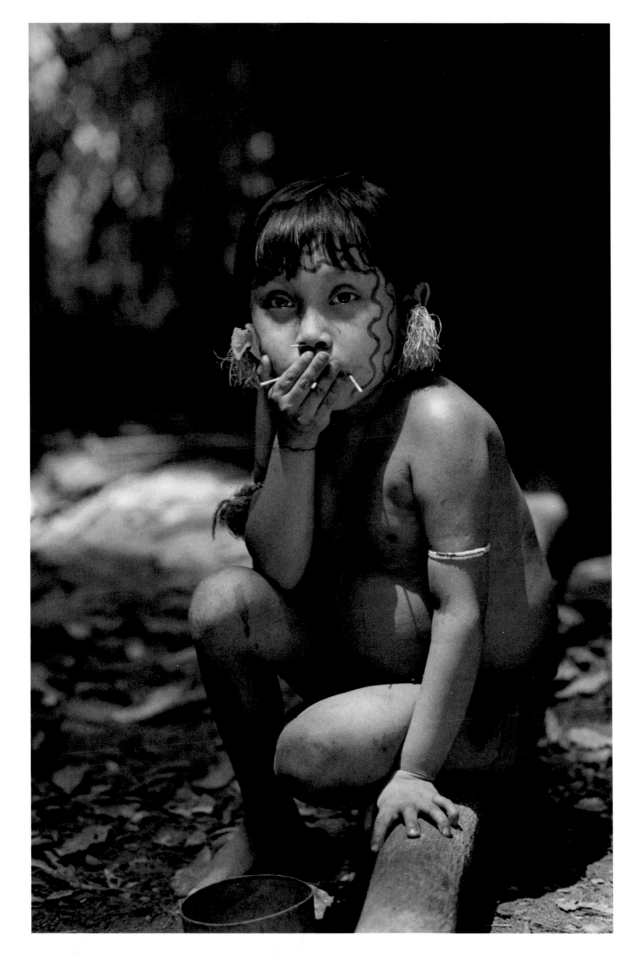

# Afterword

*People of the Rainforest*

by Vicki Goldberg

Intrepid is to photographer as wise to philosopher and dark to night. From the early days of photography men (and much later women) braved daunting obstacles to record the world. The Bisson Frères hauled their glass plates up the icy slopes of the Alps, Timothy O'Sullivan plunged through uncharted rapids in the American West, John Thompson risked stoning at the hands of angry Chinese, all to document little-known places and people.

Valdir Cruz is of this lineage, having ventured several times deep into the Amazonian rainforest in Venezuela and northern Brazil. Panther and poisonous snakes, malaria, and hostile tribes are plentiful there, and native porters have been known to rob white men and leave them to their luck in the wild. Cruz brings back a surprise from his treks, not just because his pictures of the Yanomamo and Yanomami Indians show people still largely untouched by modern technology and commerce, but because these images are placid, informal, relaxed, and often unposed. The subjects may be exotic to us, and according to the photographer they are generally extremely reluctant to be photographed, but they obviously trust this outsider in their midst and react with a generous ease.

These photographs lie halfway between anthropology and art. "Halfway between" may be the safest place to be today, when conflicted feelings about interest in tribal people run so deep that even curiosity about their appearance can be read as exploitation. Anthropologists themselves, aware of photography's (and anthropologists') subjectivity, now criticize their own visual histories, once thought to be honest, flat-footed scientific documents: people posed stiffly in rows or glumly displaying their crafts and finery.

On the other hand, art photographers have been known to remove their subjects from all context and photograph them like pre-Columbian ritual objects isolated on pedestals in a

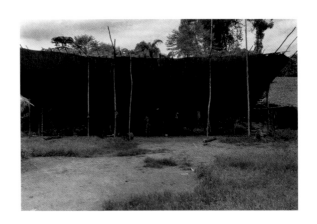

museum. Most notable here is Irving Penn's 1974 *Worlds in a Small Room* (Secker & Warburg 1974), images of natives all over the world positioned before paper backdrops, as abstractly and elegantly as fashion models.

Cruz claims that he is just trying to be an observer, to register things as he sees them.[1] Documentation, then, but happily not without art. He finds the play of sunlight irresistible as it filters unpredictably over the backs of two women digging for crabs, or glints on a man's legs as he stands in the shade. Though Cruz says he does not want to make the print speak more insistently than the subject, he will not neglect his craft, and these selenium toned black-and-whites have a lovely color and quality.

Despite the current distrust of photography, the certainty that it not only can lie but does so willfully, some of these pictures encourage the old-fashioned assumption that they are instant exemplars of truth. Their very casualness and matter-of-factness, a reluctance in some cases to make something too studied or too beautiful, invite us to consider them as evidence. The family intent on cutting up an animal and the groups that sit around painting bodies or waiting for rituals to begin do not notice the photographer, who has not stolen up on them but borrowed a moment once he became so familiar they could ignore him.

A boy unthinkingly making a face, two boys with mouths distorted by tobacco plugs they chew on, and the children who flirt or cover their mouths present themselves as unrehearsed documents– sweet, faithful accounts of simple facts. Images like these–never haphazard, sometimes spontaneous, always deliberate, calm, and coherent–suggest a society that is relatively ordered, unrushed, and heavily invested in ritual tradition.

In one major respect the formal means mirror and support the images' content: the close-valued scale of grays without high contrasts promotes a subtle affinity between forest and humans–a subdued sense of uniformity over everything. The leader posing in his regalia and the men emerging from vegetation are tonally all of a piece with their surroundings–a kind of glancing metaphor for the Indian feeling of oneness with the rainforest.

Born in 1954 in southern Brazil, Cruz emigrated to America in the late 1970s, but he only discovered his interest in photography in the 1980s. In the mid-'80s he took a course with George Tice, who is known for his superb printing, and eventually assisted Tice in printing two portfolios of work by Edward Steichen.

Cruz's interest in his home town and his native land has grown with his distance from them in space and time, a often happens to emigrés wrenched for whatever reason from surroundings so familiar they are essentially unseen. In 1994 he photographed several rainforest leaders from the Amazon who had come to New York to plead the cause of the rainforest to the UN. The following year he went into the forest on his own with the assistance of two of those men.

It is no easier to get permission to travel in these areas than it is to journey through them, but he went in again with Patrick Tierney, who was writing a book about the Yanomami, and then once more with the help of a Guggenheim grant, assistance from Leica, and the support of a priest who had worked extensively with the Indians. "In the last years," he says, the rainforest has become "all I live, all I eat, all I drink."[2]

After the first trip, he traveled with a nurse, a microscopist, medicines, gifts, and a commitment to bring back a report on the medical condition of the Indians. Cruz has, in fact, spent more time writing down this medical information than photographing, but the benefits of the medicine the travelers bring with them account for much of the trust and cooperativeness so evident in his photographs.

The posed portraits, and even the unposed pictures, evoke complicated responses of a more political than aesthetic cast. Our attitudes toward this kind of picture making have always been complex, and the edge of our self-consciousness has been sharpened in recent years. The subjects are

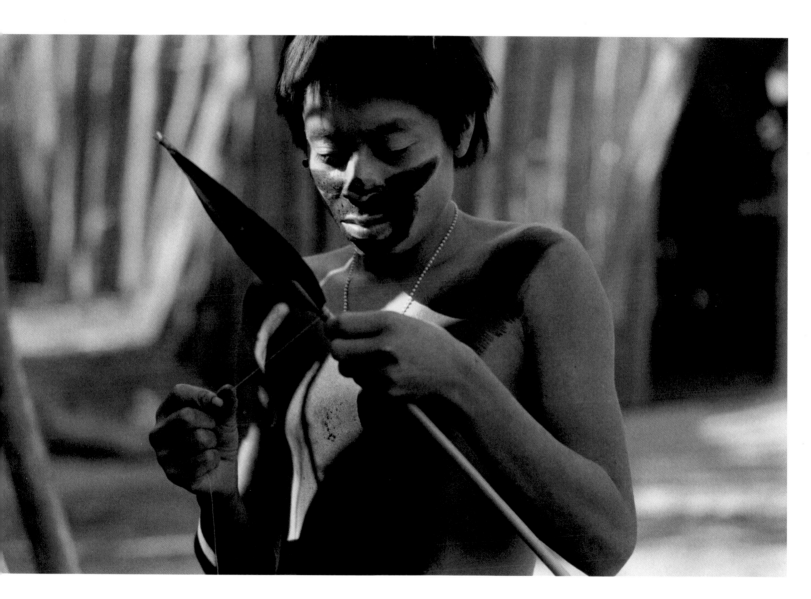

The arrow maker, Brazil, 1996

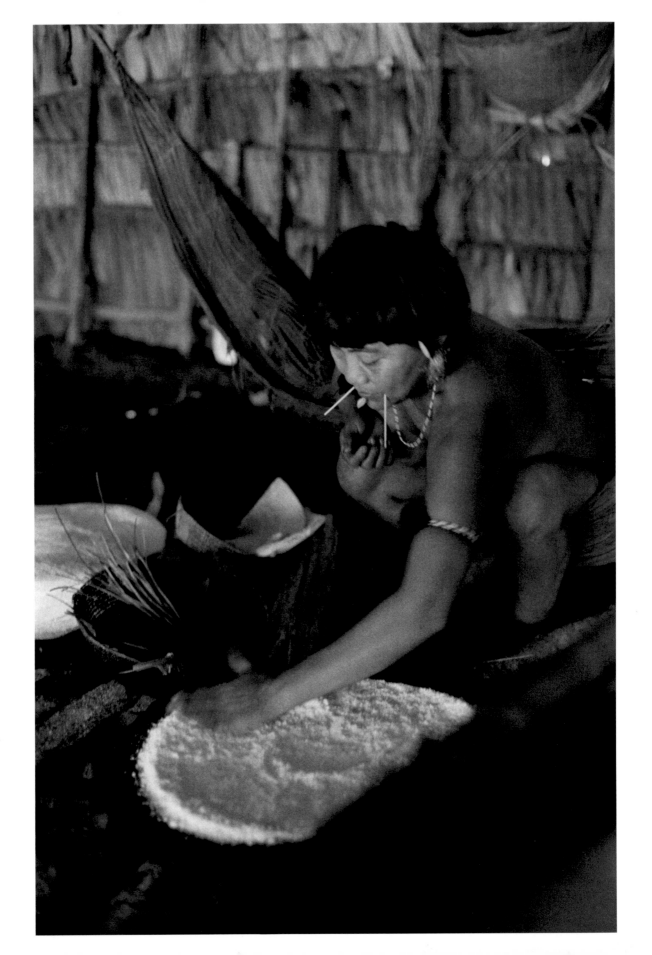

sometimes handsome and the approach respectful, but after that is said we are left to sort out our reactions to the subject matter and the history of its portrayal.

Pictures of Indians made in the last couple of centuries fall into several types. Before photography, images of the native tribes of the Americas looked astonishingly like Europeans in peculiar states of undress. Before and after photography, the same people were seen as savages, noble savages, and, as time went on, "primitive" people from the childhood of human evolution–or as proud warriors, oppressed people, dignified examples of dying races, and, in endless variations, exotica, human oddities, and the "other."

Cruz's images represent dying races, or at least dying cultures–because of what we know, not what the photographs show. In effect that puts his pictures into the same category as Edward S. Curtis', if only because the Indian situation in South America today is similar to that of North American Indians early in the century when Curtis photographed them.

In Curtis' time, when the Indians of the American West had been vanquished and no longer posed a threat to settlers, it was generally agreed that the cultures, and quite possibly the people themselves, were doomed to extinction. This thought made liberal thinkers cringe, but did not prevent continued damage and newly hostile laws. Curtis set out to document cultures he considered both worthy and noble before they disappeared. His massive photographic campaign covered a vast territory; the multi-volume *The North American Indian* was published between 1907 and 1930. For his part, Cruz plans to document as many of Brazil's indigenous tribes as he can; they number well over 150.

The South American Indians had been conquered and decimated even earlier than those in North America, and soon the rubber boom and coffee plantations encroached on their lands to the point where Indian survival was doubtful.[3] They survived nonetheless, partially through the efforts of European settlers to protect them, but history has repeated itself in the last decade.

The gold rush that began in 1987 in northern Brazil is estimated to have killed 15% of the Yanomami, most from disease they had no resistance to, many from violent conflict as well.[4] The mines severely degraded the environment, polluting the water systems with mercury, and the miners

destroyed game and game lands, an ecology that Indian societies depend on and are taught through custom, ritual, and myth to preserve.[5] Between 1990 and 1992, the Brazilian government moved to recognize Indian claims on the land and to restrict mining. But though the depredations have been slowed, they have not been halted.

Some of the Yanomami whom Cruz has photographed have adopted many of the new invaders' customs and materials, eating foreign food, and incorporating discarded plastics into their buildings. Other tribes have nearly forgotten their ceramic craft, their music, their body painting patterns and in effect their selves, and are only now reclaiming their own traditions–they have lost their identity without being equipped to take on a new one. Some think this is the fate of all the native tribes, who cannot exist as they are outside the lands they have hunted and farmed for generations, whose culture may be erased by settler commerce, greed, and diseases, and who are almost wholly unprepared for contemporary Brazilian life.

So Cruz presents these people less lavishly and sentimentally than Curtis did other threatened natives, but with a similar regard for their beauty (and in Cruz's case, some of their daily awkwardness) and a similar call on our serious attention. Curtis carried costumes and props with him and dressed some subjects in other tribes' clothes. Today he is reviled as a falsifier, but the descendants of his subjects often consult his images because they are the only historical information that is left.

It will be one of the terrible ironies of our time if we preserve the image of the rainforest and destroy the thing itself and its inhabitants. While that possibility hangs in the balance, here they are, forest and people–images to arrest the eye and, however calm and lovely they may be, provoke the mind's unease.

1. Interview with Valdir Cruz, July 7, 1997.
2. Interview with Valdir Cruz, July 7, 1997.
3. See John Hemming, *Amazon Frontier: The Defeat of the Brazilian Indians* (London: MacMillan, 1987), pp. 466-73.
4. Gordon MacMillan, *At the End of the Rainbow? Gold, Land and People in the Brazilian Amazon* (London: Earthscan, 1995), p. 48.
5. See Gerardo Reichel-Dolmatoff, *The Forest Within* (Dartington, Totnes, Devon: Themis Books, 1996), passim.

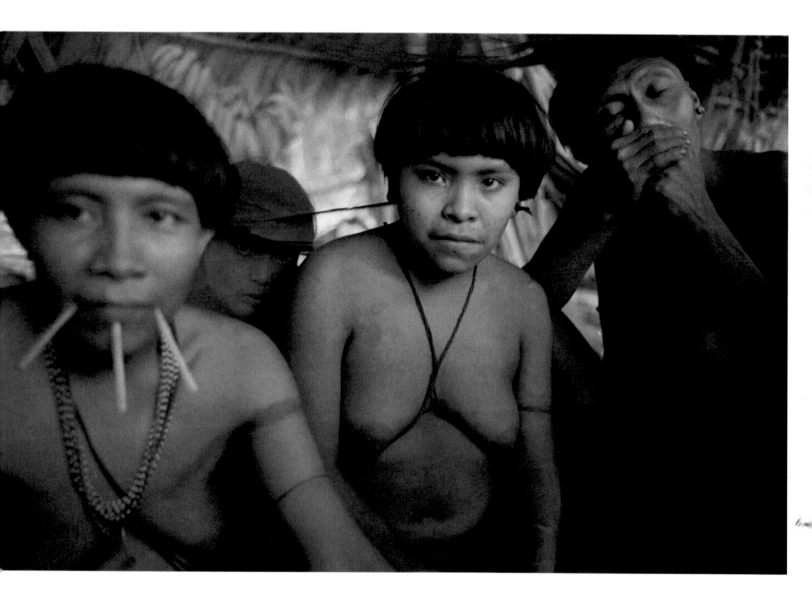

Early visitors at my hammock, Venezuela, 1996

# Biography

## Permanent Collections

- National Anthropological Archives of the Smithsonian Institution–Washington, DC
- Tampa Museum of Art–Tampa, FL
- Lehigh University Art Gallery–Zoellner Art Center–Bethlehem, PA
- The World Bank–Washington, DC
- Ringling Museum of Art–Sarasota, FL
- The New York Public Library –New York City
- The Museum of Modern Art–New York City
- The Brooklyn Museum–Brooklyn, NY
- The Museum of Fine Arts–Houston, TX
- The National Arts Club–New York City
- Instituto Cultural Itaú–São Paulo, Brazil
- MASP–Museu de Arte de São Paulo–São Paulo, Brazil
- Fundação Cultural de Curitiba–Curitiba–Paraná, Brazil
- The Cathedral of St. John the Divine–New York City
- Paine Weber Collection–New York City
- Readers Digest Collection–New York
- John Bennette Collection–New York City
- Kim Esteve Collection–São Paulo, Brazil
- Sig Bergamin Collection–São Paulo, Brazil

## Individual Exhibitions

- Fresno Art Museum–Fresno, CA — 2001
- Galeria de Arte Fotografico–San Miguel de Allende, Mexico — 2000
- Tampa Museum of Art–Tampa, FL — 2000
- Bath House Cultural Center–Dallas, TX — 2000
- Houston Center for Photography–Houston, TX — 2000
- Ringling Museum of Art–Sarasota, FL — 1999
- LGC Arte Hoje Gallery–Rio de Janeiro, Brazil — 1999
- Barry Singer Gallery–Petaluma, CA — 1998
- Museo de las Americas–Denver, CO — 1998
- Throckmorton Fine Art–New York City — 1997
- LGC Art Hoje Gallery–Rio de Janeiro, Brazil — 1997
- LGC Art Hoje Gallery–Rio de Janeiro, Brazil — 1996
- MASP–Museu de Arte de São Paulo–São Paulo, Brazil — 1996
- Fotofest–Houston, TX — 1996
- St. Peters Church–Millbrook , New York — 1995
- Devereux Demetriat Gallery–New York City — 1994
- The Cathedral of St. John the Divine–New York City — 1994
- Collectors Photo Gallery–São Paulo, Brazil — 1993
- 242 Gallery–New York City — 1992
- UNESCO–Porto, Portugal — 1991
- MIS–Museu da Imagem e Som–São Paulo, Brazil — 1991
- Galeria Banco do Brasil–Guarapuava, Brazil — 1991
- Fundação Cultural de Curitiba–Curitiba, Brazil — 1991
- Kim Esteve Gallery–São Paulo, Brazil — 1990
- 242 Gallery–New York City — 1989
- National Arts Club–New York City — 1987
- Germain Gallery–New York City — 1984
- Parque de Exposições L.Werneck–Guarapuava, Brazil — 1982

## Group Exhibitions

- El Museo del Barrio–Latin American Photographers–NYC — 2000
- Centro Português de Fotografia-Labirinto e Identidades–Porto, Portugal — 2000
- Kunstmuseum Wolfsburg-Brasilianische Fotografie–1946–1998 — 1999
- SoHo Photo–New York City — 1999
- Brooklyn Museum–Recent acquisitions–Brooklyn, NY — 1999
- Bath House Cultural Center–Dallas, TX — 1999
- Itaú Cultural–Campinas, S.P. Brazil — 1999
- Instituto Cultural Itaú–São Paulo, Brazil — 1998
- Fotofest–Houston, TX — 1998
- Brooklyn Museum–Brooklyn, NY — 1996
- FAAP–Espaço Cultural–São Paulo, Brazil — 1995
- Bonni Benrubi Gallery–New York City — 1994
- SESC Pompéia–São Paulo, Brazil — 1993
- MIS–Museu da Imagem e Som–São Paulo, Brazil — 1993
- The Camera Club of NY (Benefit Auction)–New York City — 1992
- Hunterdon Art Center–Clinton, NJ — 1992
- Charas/El Bohio Cultural and Community Center–New York City — 1992
- MASP–Museu de Arte de São Paulo–São Paulo, Brazil — 1992
- MASP–Museu de Arte de São Paulo–Pirelli Collection–Brazil — 1992
- Carla Stellweg/Zocalo, Inc.–New York City — 1992
- Bullet Space–New York City — 1990
- MIS–Museum of Image and Sound–São Paulo, Brazil — 1989
- Dutchess County Arts Association–Barret House–Poughkeepsie, NY — 1989

## Awards

- Recipient of The John Simon Guggenheim Memorial Foundation "publication subvention" to ensure publication of *Faces of the Rainforest* in a book format. (2000)
- Recipient of the John Simon Guggenheim Fellowship (1996)

## Represented by

- Throckmorton Fine Art, Inc. — New York City
- Sicardi-Sanders Gallery — Houston, TX
- LGC Arte Hoje — Rio de Janeiro, Brazil
- Galería de Arte Fotográfico — S.Miguel de Allende, México

# Acknowledgements

I'd like to express my sincere thanks to the organizations, individuals, and friends who have believed in this project and have made it possible. They include The John Simon Guggenheim Memorial Foundation; Leica Camera Inc., Professional Loan Program; Kodak; Rainforest Foundation - US; FUNAI (Fundação Nacional do Indio) Brasilia, DF, Brazil; FUNAI (Fundação Nacional do Indio), Roraima, Boa Vista, Brazil; CIR, Conselho Indigena de Roraima, Boa Vista, Brazil; FNS, Fundação Nacional da Saúde, Boa Vista, Roraima, Brazil; DSY, Distrito Sanitário Yanomami, Boa Vista, Roraima, Brazil; CAICET, Centro Amazonico para Investigacion y Control de Enfermedades Tropicales, Puerto Ayacucho, Estado Amazonas, Venezuela; Salesian Missions, Upper Orinoco River, Venezuela; Fotofest, Houston, Texas; Houston Center for Photography; and powerHouse Books, New York City.

## U.S.A.

Ana Valéria Araújo, Jean Caslin, Craig Cohen, Fabio Costa, Sidney Cruz, Silvia Cruz, Evelyne Daitz, Darcie Eggers, Esa Epstein, Ron Fouts, Abe Franjlick, Maria Teresa Garcia Pedroche, Kenneth Good, Christine Halverson, Erika Harrsch, Daniele Hayduck, Robert Hennessey, Keiko Kato, Brian Lav, Edward Leffingwell, Marian Mc Whorter, Barbara Millstein, Margo Morrison, Dean James Morton, Laurie Parise, Daniel Power, Peter Kasovitz of K & M Camera, Susan Kismaric, Spencer Throckmorton, Patrick Tierney, Julia Van Haaften, Wendy Watriss and Zezé Weiss.

## BRAZIL

Claudia Andujar, Paulo Roberto Azevedo Júnior, Edgard Dias Magalhães, Luiz Eduardo da Gama e Silva, Davi Kopenawa Yanomami, Julio and Maria Martins, Leda Martins, Virginia Peña, Marcos Santilli, Ana Paula Souto Maior, Marinho de Souza, Belgerrac Vilela Batista and his family, Ari Weiduschat and Father Carlos Zacchini.

## VENEZUELA

Father José Bortolli, Javier Carrera Rubio, Paul Griffs, Claudia Kastinger, José Luiz and Helena Pacheco, and my Yanomami guides, Alfredo, Jacinto and Marcos.

**Faces of The Rainforest**

© 2002 powerHouse Cultural Entertainment, Inc.

Photographs and journals © 2002 Valdir Cruz
Preface © 2002 Trudie Styler
Essay © 2002 Kenneth Good
Afterword © 2002 Vicki Goldberg
Map © 2002 Erika Harrsch

Published in the United States by powerHouse Books,
a division of powerHouse Cultural Entertainment, Inc.
180 Varick Street, Suite 1302, New York, NY 10014-4606
telephone 212 604 9074, fax 212 366 5247
e-mail: rainforest@powerHouseBooks.com
web site: www.powerHouseBooks.com

First edition, 2002

Library of Congress Cataloging-in-Publication Data:

Cruz, Valdir, 1954-
    Faces of the rainforest / photographs by Valdir Cruz ; text by Kenneth Good and
    Vicki Goldberg ; preface by Trudie Styler.
    p. cm.
    ISBN 1-57687-137-1
    1. Yanomamo Indians. 2. Yanomamo Indians–Pictorial works. I. Good, Kenneth.
    II. Goldberg, Vicki. III. Title.

    F2520.1.Y3 C78 2002
    980'.00498–dc21

                                                                            2002068400

Hardcover ISBN 1-57687-137-1
Limited Edition ISBN 1-57687-159-2

Printing and binding by EBS, Verona
Duotone separations by Robert Hennessey
Consulting Editor Edward Leffingwell
Design by Fabio Costa

A complete catalog of powerHouse Books and Limited Editions is available upon request;
please call, write, or face our web site.

10 9 8 7 6 5 4 3 2 1

Printed and bound in Italy

| | | |
|---|---|---|
| Opening photo I | Girl from Demini-teri, Brazil, 1995 | |
| Opening photo II | Shaman, Davi Kopenawa Yanomami, Studio–NYC, 1994 | |
| End paper I | Shapono's detail, Venezuela, 1997 | |
| End paper II | Shapono's detail, Venezuela, 1997 | |

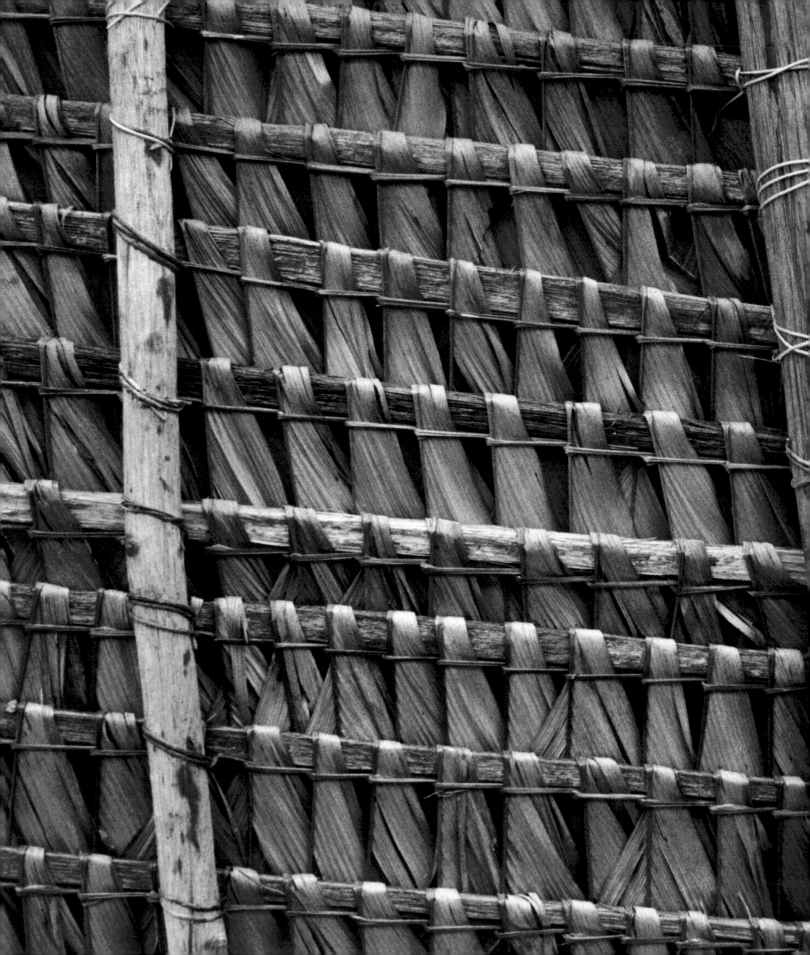